T0158251

Slivers of a Mirror

Slivers of a Mirror

Glimpses of the Ghazal

translated by
Shama Futehally

MapinLit
AN IMPRINT OF
MAPIN PUBLISHING

First published in India in 2005 by
MapinLit
An imprint of
Mapin Publishing

Mapin Publishing Pvt. Ltd.
31 Somnath Road, Usmanpura
Ahmedabad 380013 India
Tel: 91-79-2755 1833/2755 1793 • Fax: 91-79-2755 0955
email: mapin@icenet.net • www.mapinpub.com

ISBN: 81-88204-50-1

Design by Janki Sutaria/Mapin Design Studio
Printed in India

Acknowledgements

*T*HE POEMS are sourced from three books: K.C. Kanda's *Masterpieces of the Urdu Ghazal from the 17th to the 20th Century* and *Urdu Ghazals: An Anthology from the 16th to the 20th Century*, (Sterling Publishers) and *An Anthology of Classical Urdu Love Lyrics* by D.S. Matthews and C. Shackle (Oxford University Press). I have referred to the elucidation, the translations, and the general scholarship in these books to the full. K.C. Kanda, particularly, deserves the gratitude of all lovers of Urdu for making so much of its poetry accessible to them. It will be clear that I have also benefited enormously from Ahmed Ali's *The Golden Tradition: An Anthology of Urdu Poetry* (Oxford University Press); from many works by Ralph Russell; and from all the other books cited in the bibliography. I was encouraged to do these translations by my friend Vidya Rao, who conceived of the project, then handed it over, so to speak, with her usual largeness of heart. For this I will always be grateful. Dr. Zubair Qureshi, former Professor and Head, Department of Persian and Urdu, School of Languages and Literature, Gujarat University, went though the translations and Introduction with great care, correcting errors and offering comments. He was also responsible for the transliteration of the poems from Urdu into the Devanagri script. His scrupulous and exacting scholarship enables me to send this book out with more confidence. I am deeply grateful to him, and am solely responsible for any mistakes that still exist.

INTRODUCTION

*U*RDU POETRY, or *shairi* as it is called, is one of those skeins in Indian culture which seems to create greater fellow-feeling by its mere existence. In this it is a little like the early black-and-white Hindi cinema, humane and sentimental, which created a world so passionately shared by all of its generation. Like that cinema, Urdu verse has penetrated popular life as poetry rarely does. The commonest and most important form of *shairi* is the *ghazal*, or love lyric, and that is the form of which this collection is composed. The *ghazal* is often put to music, and has become a cherished form of musical entertainment. Indeed, the evergreen Hindi film song owes much to the tradition of the *ghazal*. At another level, verses from *ghazals* are frequently quoted on appropriate occasions—and usually evoke a vociferous response. The ability to recite *shairi* in this way marks out the reciter as being well-read and cultivated, and as sharing, with the poetry itself, a quality of benign understanding. Even now, there is a half-humorous tradition in the Indian Parliament where the Finance Minister ends his Budget Speech with such a verse, thus ensuring a delighted response no matter what his budget contains.

Understanding this popularity will require a look at the history of the *ghazal*, which this essay will attempt to do. But one or two broad observations may be in place to begin with. The first is that the *ghazal* is oral poetry par excellence (since it came into being before printing had acquired a widespread importance in India) and was traditionally recited to appreciative gatherings that included poets. For this reason it has almost hypnotic qualities of rhyme and metre.

The second fact is that, with the *ghazal*, a verse is always a *couplet,* which makes an eminently accessible unit. Indeed the word for couplet, '*sher*', is the root for the word '*shairi*' itself. Third, as far

as subject goes, each couplet is quite independent of the other, so that it can be enjoyed on its own. However—and this is crucial—the couplets are linked by elaborate end-rhymes, so that, as one follows the other, the audience is united in guessing which rhyme will cap the new couplet, and usually anticipating it with a triumphant shout.

The quality of poetic enjoyment to be gained in this way is obviously very different from that which a western reader commonly expects. Here there is no slow build-up of emotion or mood, nor is there any narrative development (except in forms other than the *ghazal*, which we shall briefly consider later). There is, instead, the chance to see in each couplet a flash of words brilliantly combined and weighted with meaning, much as one might see in a couple of splendid lines in Shakespeare. Subsequently, the intellectual pleasure of hearing these lines is complemented by the sensual pleasure of the thundering connections made by the end-rhymes and the metre.

This structure proved both firm and flexible enough for poets to use it at a range of levels. The greatest poets have used it to touch heights of philosophical reflection, mystical longing or erotic despair. The lesser ones create a gentler melancholy or speak of everyday ironies; a modern poet like Faiz has used it to express revolutionary fervour. To understand the peculiar narrowness and the peculiar breadth of this tradition, we need now look at its history in detail.

The History

The growth of the Urdu language is linked with the establishing of Muslim rule in north India. The Muslim presence began with the Turko-Afghan invasions starting from the 11th century, which led to the establishing of Turko-Afghan dynasties in north India and of some Muslim kingdoms in the Deccan area to the south.

In 1526, Babur, a Mughal chieftain from Farghana, defeated the ruling Turko-Afghan king, and established the powerful and wealthy Mughal empire which was to hold sway over northern India for three hundred years.

Obviously, the Muslim presence also meant the influence of Turkish, Arabic and Persian culture and language; and of these, the flourishing Persian culture soon began to predominate. As for the Persian language, it was the lingua franca of all the newcomers, and became the language of the court, which it continued to be till the end of Mughal rule. The importance of Persian culture to Muslim India can be gauged from the little anecdote about the emperor Humayun, who spent ten years at the Persian court in exile. As he prepared to return, the Shah asked him what gift he wished to take back with him, and he replied unhesitatingly that he wanted 'two Persian painters and two Persian cooks'. Whatever the truth of that story, the exquisite tradition of the Mughal miniature is derived from the Persian one; the extraordinary Mughal cuisine was an Indianised version of the Persian one; and the Mughal garden was created in an effort to reproduce the Persian garden of the mountain springs. Every kind of art from calligraphy to inlay-work owed much to its Persian forebears, so we need not be surprised that Urdu poetry is descended from the Persian.

The Tradition of Persian Poetry

There are several forms of Persian verse which entered Urdu. These included the *qasida* or ode, the content of which could be either praise or satire; the *masnavi*, a poem which could be on any subject and of any length; the *qita*, a poem like the *ghazal* but with a different rhyme scheme, but which, again, could be on any subject; and the *rubai*, or quatrain, made familiar by Omar Khayyam. A form which developed in Urdu rather than in Persian was the *marsiya* or lament for the battle at Karbala, which is recited during the month of mourning called Muharram.

However, as we have seen, these forms do not bear comparison, either in literary value or general popularity, to the *ghazal*. The word '*ghazal*', may be etymologically linked to the word 'gazelle', the cry of a wounded deer. In another derivation it may mean something like 'talking to ladies about their beauty and youth'.

Both meanings are applicable; the *ghazal* is usually a cry from the heart, and it talks; usually without success, to ladies. The Persian *ghazal*, then, originated as a short, and usually melancholy, love poem.

However, medieval Persia was the Persia of great mystics; and the love expressed in this poetry did not remain simple human love. It reached for the divine. The *ghazal* came to express an intermingling of human love (called *ishq-e-majazi*, or love of that which is seen) with mystical love, (*ishq-e-haqiqi* or love of the Truth, which is unseen). It merged them to produce that profound ambiguity which belongs to all great poetry. This tendency also meant that the *ghazal* inclined towards an abstract expression of mood, rather than towards concrete imagery or linked narrative. One feature which undoubtedly helped to hone the subtlety of these abstractions is the ellipsis allowed by Persian grammar. Ellipsis means the linking of two apparently disparate entities to form a third one, without a conjunction. It is a feature which we will meet again in the greatest of the Urdu poets.

These *ghazal*-writers, then, were creating a form where they did not use images individually created—they used symbols which would be universally understood. They were also creating a very firm structure—that inflexible casing of rhythm and metre which was to be a key feature of the *ghazal* in future.

The *ghazal's* popularity in India goes back to the arrival of the Persian language in their country, and it evolved its own kind of perfection. All these features came together to perfect the form by about the 13th century. The next century saw its greatest practitioner, Hafiz. By now the form had begun to find its way to India. Amir Khusrao of Delhi (1253–1325) has left us the piquant offering of a *ghazal* in which a line in Persian alternates with a line in the Indian language, Brij Bhasha. This combination illustrates the coming together of elegant Persian metaphysics with the emotional force of indigenous love poetry.[1] Such a coming together was to prove crucial for the vitality of the Indian *ghazal*. A hundred years after Amir

Khusrao came Hafiz of Shiraz, one of the greatest practitioners of the *ghazal* in Persia. But first we must look at that other coming together, of the Persian language with the Indian ones, a mingling that was to create Urdu.

The Growth of Urdu

When Turkish, Arabic and Persian entered India together, they confronted the various north Indian dialects which were the forerunners of modern Hindi, and which were written in the Devanagri, or Sanskrit script. As we have seen, the influence of Persian far outdid that of Turkish and Arabic, and Urdu resulted largely from the mingling of Persian with early Hindi. The word 'Urdu' is a Turkish word meaning 'camp'—itself suggestive. One presumes that it was at the army camp—in those days an elaborate affair which might include families and harems—that interaction between the newcomers and locals was most required.

The new language took a definite form which made it develop fast. The basic format (grammar and syntax) remained that of the indigenous dialect (i.e. that of medieval Hindi) but glamorous foreign words were rapidly added to its vocabulary. Contemporary Indians will recognize in this their own habit of speaking Hindi or Tamil or whatever, with a generous admixture of English words wherever they feel the need. It is the perfect form of expression in a fast-changing society. Even today, at the simpler level, Urdu and Hindi are exactly the same. It is when more complicated vocabulary is needed that speakers of Urdu use words derived from Persian, and speakers of Hindi use words from Sanskrit.

By the middle of the 17th century Urdu had replaced Persian in daily life even at the palace, if not in the official work of the court. Hence it now came to be written in the Persian rather than the Devanagri script. And Urdu poetry, needless to say, had grown along with the Urdu of everyday life.

The Growth of Urdu Poetry

It is popularly believed that the first Urdu poet was Amir Khusrao of Delhi (1253–1325), although, as we have seen, he also amused himself by writing *ghazals* in which Persian alternated with Brij Bhasha. Some scholars dispute the claim that Khusrao was the first Urdu poet, and suggest that this belief is only based on the fact that Khusrao was the first to use the Persian *script,* which has now come to be universally associated with Urdu. If we are to go by this theory, then other poets, contemporary or earlier, who were using the Devanagri script, were still arguably writing in Urdu.

Another mild controversy surrounds the location of this early development. Some believe that Urdu poetry took root not in north India, but in the Deccan Muslim kingdoms to the south. This would be in spite of the fact that Urdu developed from northern, not southern dialects. Some of the most striking of the early poets, (like Sultan Mohammad Quli Qutab Shah of Golconda) are indeed from the Deccan, and use the Deccani, or Dakhini, form of Urdu, which northerners still consider charmingly incorrect.

Whatever the truth, it may be safely said that a landmark date in the growth of Urdu poetry is 1700, when the southern poet Wali Mohammad Wali or Wali Deccani (the author of Poem 17) is said to have visited Delhi.[2] (Readers may notice that the original of Poem 17, written by him, has an attractive touch of Deccani Urdu.) This visit, and the interchange that began with it, started a synthesis of Deccani south and Persianised north, to the benefit of Urdu. By now the Mughal empire was on the decline, and quite possibly the waning of Persian contributed to the rise of Urdu. The crumbling of empire, and of its edifice of unquestioned authority, also encouraged the growth of free enquiry rather than dogma, of individual mysticism rather than collective belief, and of fearless satire: all contributing to the complexity and subtlety of the poetry. At the same time, an elaborate court life did exist, enough to allow a system of patronage which supported the poet as it did other artists. The poet of course had to be

prepared to write panegyrics, and celebratory or mournful poems as his patron required. There was also a system in place where a young poet would spend years as the *shagird* or student of an older one, who was called the *ustad* or teacher. Zauq, and for a brief period Ghalib, were for instance, the *ustads* of the last Mughal emperor, Bahadur Shah Zafar, who was a more accomplished poet than royals usually are. The *ustad* had to 'correct' the student's work, and the formal requirements of Urdu poetry being what they are, such 'correction' does not seem out of place as it would with other kinds of poetry. It was traditionally the *ustad* who chose a *takhallus* or pen-name for his student. The pen-name was always carefully chosen; 'Zauq' for instance, means 'taste' and 'Dard' means 'pain'. It is by the pen-name that we know most of the great poets.

The Ghazal in its Social Setting

To recapitulate what the *ghazal* inherited from its Persian origins: it was, first, a love-poem which often addressed human and divine love simultaneously. It was abstract in nature, dealing with symbols rather than with images created by the individual poet. It made no attempt to either build up a narrative or sustain a mood. Therefore, it could consist of couplets that had no relation to each other except that of skillfully executed metre and rhyme; equally, therefore, these couplets could be enjoyed either separately or together. The emphasis on rhyme and metre had developed because while from the very beginning written down in what was known as Diwan, it was also an oral poetry meant to be recited to discerning and appreciative gatherings.

This is the structure which now adapted itself to Mughal society so closely that the poetry seemed to become a microcosm of the society itself. Needless to say, the society was a male-dominated one, where the melancholy pleasures of love were available to the man rather than to the woman. In any case, 'respectable' women lived in purdah and strictly within the conventions of their arranged marriages. The love, therefore, which regularly drove the poet to

distraction was rather like the love in medieval French romances: a chance glimpse of a beautiful face would leave the poet pining, able to rely only on glances and messages and 'wanderings in her lane'. Of course more tangible relationships were to be had with courtesans, who were often highly accomplished singers and dancers, and presumably capable of providing mental as well as physical companionship. Following Persian habit, the beloved might well be a beautiful young man. The pronoun '*woh*' in Urdu, always used for the beloved, can equally mean 'he' or 'she'—and of course it can always mean God.[3]

Such a scenario produced its own dramatis personae. The beloved is, predictably, always cruel and indifferent. The lover usually has a rival or *raqib* and is subject to the hollow moralizing of a sheikh, or holy man ('The sheikh who never/needs to bend/what does he/know of prayer?' says Dagh Dehlvi in Poem 5). There is the all-important *qasid* or messenger whom Hali berates in Poem 6 by telling him to stop complaining about his own troubles—('Let's see the answer she sent me').

The setting, too, is usually known—the lover drinks away his troubles in the *mai-khana*—the wine-house or tavern where, incidentally, the sheikh is often seen to be sneaking in. Or he wanders up and down the *kucha* or lane of his beloved. A torn collar, *chak-e-gireban,* or a stained hem reveals his distracted plight.

The code of symbols, too, occupied real space as much as poetic space. After all, entities like the garden, the cup-bearer, and the rose (all clearly revealing their Persian origin) were very much a part of elite Muslim life. They were equally part of the life of its poetry, and in the poetry the garden becomes the garden of the world, and the rose becomes the beauty for which the nightingale (read lover) keeps wailing. Perhaps because of the Islamic penchant for symmetry, symbols appear in pairs: the beautiful rose (*gul*) and the plaintive nightingale (*andaleeb*), the wine (*mai*) of life and the cup-bearer (*saki*) who allows you some intoxicating sips, the oil-lamp (*shama*) of beauty

and the moth (*parwana*) which burns itself in its irresistable flame. The nest (*nasheman*) which is the lover's heart is set against the cage (*kafas*) which is the world; or against the lightning (*barak*) which is the cruel striking of Fate.

As we know, however, the *ghazal* moved from a concern with individual love to a wider one, and to wider reflections on life. There are important symbols that reflect Sufi experience—the veil, for instance, which now is not just the veil that hides a beautiful face, but one which hides the face of the Divine from its seeker ('When I awoke at last, no veil was seen', says the mystic Dard in Poem 19). There is the mirror, which represents the earthly being who mirrors the divine one, and which sees God as a mirror-maker, as Iqbal does in Poem 9. The Islamic symbol of the mystic Spring, source of all life, given resonance by memories of the beloved springs of Persia, comes to stand for all beauty, joy, vitality. For Hali (Poem 14) the Eternal Spring is none other than the love and praise of ordinary earthly beauty.

The *ghazal* also drew heavily on Central Asian legends, like the love stories of Laila and Majnun or Shireen and Farhad. Since Islam believes in both the Old and the New Testaments, and in Christ as one of the prophets, Biblical characters take the place which mythical characters might do in another tradition. References to Christ ('Ibn-e-Mariam' or Son of Mary) are common, as are references to Mary herself. Poets often speak of the beauty of Joseph, the suffering of Jacob, the love of Zuleikha, and other Biblical events or characters. For Mir (Poem 10) 'each hour burns beautiful as Yusuf' or Joseph. Finally, the *ghazal* frequently refers to genuinely historical characters like Alexander or the great king Jamshed.[4]

It will be obvious that, in the use of symbols as well as of legends and history, if the poets had stayed blandly with the conventions, we would not find their poems worth reading today. The symbols, particularly, provide points of reference which are endlessly explored, extended, combined in new ways, or overturned. Thus the Sufi mirror can also be a hundred different things to a hundred

different haughty beauties, as can the veil. The oil-lamp of beauty can become the lamp of life itself, beginning to flicker towards dawn. Perhaps most important, the oil-lamp was in fact burning away in the *mushaira* or recital, and was placed by turns in front of whichever poet was being invited to read. The *mehfil* or gathering itself became that gathering called life, from which, as Dagh says in Poem 11, 'we leave with gutted hems, when/snuffed out by life'. Such self-reflexiveness became common in a society where life and art fitted so closely that they turned themselves into a hall of mirrors.

The Format of the Ghazal

The first couplet of a *ghazal* is called the *matla*, and this is the one which sets the format for the metre and the rhyme. Sometimes the metrical pattern was actually decided in advance and sent to all the poets invited to a *mushaira*; the poems they recited were then expected to follow it in what is called a *tarahi mushaira*. The first two lines of the *matla* were rhyming ones, and as we have seen, the rhyme may be followed by a word or phrase which remains unchanged (*radif*). Subsequent to the *matla*, the second line of every couplet had to rhyme with the two lines of the *matla*, so that the rhyme-scheme became AA, BA, CA, and so on. The length of the rhyme obviously added to the challenge of bringing off each rhyme with credit; that is with originality, wit, and that poetic rightness which defines itself. The challenge certainly added to the excitement of the audience in anticipating the rhyme. When a poet was considered to have produced a praiseworthy couplet, he was rewarded by thunderous exclamations of praise, known as *daad* or applause.

The metre and rhyme are considered to be the *zameen* or ground of the *ghazal*. Since the poet was inflexibly bound to it, the audience was perfectly willing to let his fancy roam in terms of content, and for every couplet to have a different subject. It is possible that in oral recitation, the disparate themes of the couplets actually helped to hold the attention of an audience, as a single theme would not have. In fact there can be great charm in having a gravely

metaphysical thought followed by a quirkily humorous one, as long as each is attractive in itself.

The final couplet of a *ghazal* is called the *makta*. This is a kind of signature verse, and usually includes the pen-name of the poet, so that authorship can be remembered. It is also, usually, a little lighter and of a more personal nature than the rest of the poem. A good example would be Ghalib's signature verse in Poem 15. At the end a deeply serious poem about love, longing, and the nature of the Divine, he ends: 'These mystical reflections, these wise/pronouncements, Ghalib!/You'd have been proclaimed The Wise, had you been/less fond of wine'.

The Ghazal's History

We have seen that the great period of the Urdu *ghazal* in India began with the eighteenth century. The visit of Wali Deccani to Delhi had brought about a life-giving synthesis of north and south, and the Mughal empire was in that state of decline which seems to be peculiarly favourable to the arts. The famous poets of this time were Dard (Poems 1, 11,19), Sauda (Poem 8), and Mir (Poems 4,10).

Dard (1721-85) is the poet who, more than any other in the tradition, is considered a mystic almost more than a poet. The following couplet encapsulates his vision:

> If your Glow itself remains unseen
> What remains is all the same: seen, unseen
> (Poem 19)

Sauda earned fame as a satirist of society and of orthodoxy:

> You may be right,
> O holy one,
> in saying
>
> that all
> God's gifts
> are blessed;

but wine and small
 kebabs are still
a cut above
 the rest

(Poem 8)

Mir, or Mir Taqi Mir, to use his full name, was a soul who saw an effulgence in all earthly things:

each hour
 burns

beautiful
 as Yusuf
why let it
 slide…

(Poem 10)

With the sack of Delhi by Nadir Shah in 1739, the centre of Urdu poetry shifted to the wealthy court of Awadh, or Lucknow. Here, the Nawab and his courtiers patronized culture almost to the exclusion of governance. Several talented poets flowered in this benign shade, of whom Insha is represented here. Like other Lucknowi poets, he is known for his verbal brilliance and straightforward eroticism (one of his *ghazals* is entirely about an *angiya* or bodice) but the depth and the sombre mood of the poem represented here make it his most famous:

When did the heavens bring us peace
 revolving round each sphere?
The mercy is, we friends, we few
 are together here.

(Poem 18)

During the reign of the last Mughal emperor, Bahadur Shah Zafar (the reign was from 1837–1862), who was himself a significant poet, the *ghazal* enjoyed a revival at the court of Delhi. Bahadur Shah's throne was safe as long as he remained a puppet of the British,

which allowed for some years of relative security. The poets of the period include Momin, who is unabashedly a love poet; his verse also contains an intensity of personal feeling which places it apart from the formal lamentations of other *ghazal*-writers:

> How, like a gift
> your smile at times
> made of my pain
> a shrine at times, how
>
> might I not
> remember?

(Poem 2)

One unusual feature of this *ghazal* is its continuity, which in fact is a characteristic peculiar to Momin.

The poet Zauq also belonged to this second golden age of Delhi. His weighty impressive manner lent itself to the *qasida* or ode, rather than to the *ghazal*, and one of his *ghazals* which is included here is a good example of his grave and measured style:

> Of little use your wisdom here;
> my wit more useless still
> What is to be, will be, while we
> declaim our fill.

(Poem 7)

But the figure who towers over the period, and indeed over the entire tradition, is undoubtedly Ghalib, whose supremacy has never been questioned. His natural genius was complemented, in poetic terms, by the searing experiences of his life, no less than by the agony of his times. He was destined to see all his seven children die in infancy, as also to see the death of the mistress who was his greatest emotional support; to suffer financial hardship and uncertainty; and to witness in his beloved Delhi the horrendous human suffering that followed the crushing of the revolt of 1857. Through all this his naturally joyous and ardent nature could not be quenched; he not

only delighted in the beauties of this world, but retained a dazzled wonder in the Divine which edges all his poetry. However, he was very far from being an orthodox believer, and many amusing anecdotes provide evidence of his half-wary, half-humorous attitude to religious dogma. 'I agree', he is supposed to have said once, 'that Allah does not listen to the petitions of us wine-drinkers; but once you have the wine, what would you petition for, anyway?'

All this taken together means that there is hardly any emotion or state of mind which has not been explored in Ghalib's poetry, and that from a myriad perspectives. Not surprisingly, he is an extremely 'difficult' poet: allusive, elliptical, intense. He wrote in Persian as well as Urdu, and favoured the elliptical Persian method which condenses meaning almost to breaking-point. It may as well be said at once that problems of translatability have meant that the poems of Ghalib included here in no way do justice to the range, power, and complexity of his verse.[5]

To get a glimpse of these qualities we need perhaps a close analysis, rather than a translation, of an individual couplet. The famous first couplet of his collected works, the *Deewan-e-Ghalib* goes as follows:

Naqsh-faariyadi hai kis ki shokhiye tehreer ka
Kaghazi hai pairahan har paikar-e-tasweer ka

In a word-for-word translation, this would be:

Outline-complainant-of-whose-gay/cheeky composition?
Paper is the dress of each appearance in the painting.

To unscramble this I will fall back on the lucid translation-cum-explanation provided by Ahmed Ali.[6] His translation goes thus:

Of whose gay tracery is the picture
a complainant?
Papery is the dress
Of each figure face in the painting.

This is Ali's explanation: 'This refers to the ancient Persian custom by which a complainant appeared before a judge wearing a dress made of paper…Ghalib uses this parabolically to suggest the illusory picturesqueness (deceit) of life and the pain it brings with it…'

Presumably the quivering complainant who stands before the Great Judge, complaining about the deceitfulness of life, is the common man.

As suggested earlier, one of the factors which made life seem ephemeral and illusory to Ghalib must have been the swiftness with which normal, decent existence turned into a nightmare as the British suppressed the revolt of 1857. The life and culture of the Mughal court ended with brutal abruptness. The poet Dagh Dehlvi, who was perhaps next in importance to Ghalib at this time, had to leave Delhi and seek refuge in the courts of Rampur and Hyderabad. Perhaps the following verse has a touch of autobiography about it:

> This pinch of dust was joined
> to all that lives on earth
> and then the skies descended
> in unrelenting wrath –
>
> (Poem 23)

With the ending of the Mughal empire, and the arrival of the 20th century, poetry entered the realm of the middle class. Hali (1837–1914) was humbly born, as was Iqbal (1873–1938). It is significant that the work of each seems to address a larger world than writers of *ghazals* had hitherto done. Hali is best known for a long poem (not a *ghazal*) called the *Musaddas* which laments the state that the Muslim community has come to. Iqbal, too, is a poet with a message—his *shikwa* or complaint is on the same subject as Hali's *Musaddas*. Iqbal's complaint is to God himself. Iqbal's powerful rhetoric is on view in Poem 27:

Make selfhood so unquestioned
That when allotting fate
The Lord's Himself constrained to say
'Your life—what shall it be?'

(Poem 27)

Iqbal's poetry reflected his philosophical and political concerns. Although he was the first Urdu poet to be influenced by Western civilization and culture, he ended up as a crusader for Islam and was an early proponent of the idea of Pakistan. By one of those paradoxes in which Indian history abounds, he is also the author of the song *Saare Jahan Se Accha*, which so stirringly celebrates the idea of India that it has become almost as important as the Indian national anthem.

Further into the 20th century, a more 'modern' note makes itself heard. For this reader, at least, a kind of semi-existential despair can be seen in the *ghazals* of Akbar Allahabadi, Sahir Ludhianvi and Firaq which are translated here. If Akbar Allahabadi says, 'In this glowing/market/I have no will/to buy' (Poem 24), Sahir Ludhianvi talks of this 'fretful/world, this weary/swirl of words' (Poem 28). Firaq traverses 'Again the same/old mile, again/the same mile-stone' (Poem 25).

This despair sounds different from the pleasurable melancholy of the earlier *ghazals*, which was secure in the knowledge that beauty and love existed, if only the poet had the good fortune to attain them. All these three poets functioned very much in the world of the 20th century. Akbar Allahabadi was a lawyer who later became a judge. Sahir Ludhianvi, although he was born into a feudal family of the north, took himself and his talent to Bombay, where he became one of the best-loved composers of the Hindi film song. Firaq, who was born Raghupati Sahai, was a famous teacher of English literature at Allahabad University.

As the Western literature of the 20th century produced not just its absurdist despair but also its Brechtian vision of revolution, so

Urdu poetry produced its own towering revolutionary voice. Faiz Ahmed Faiz (1911–1984) was born in Lahore, and remained a Pakistani citizen. Political involvement, which included a spell of imprisonment, honed his Marxist ideology, and he declared dissent from the traditional romanticism of *shairi* in a famous poem which says, 'Do not ask me, my love, for that earlier love…' Elsewhere he seems to be giving notice to the mythical beloved of the Urdu *ghazal* that the time for romantic love is past: 'The world has estranged me from thoughts of you/The sorrows of earning a living cling to the heart even more than you do'.

The poem translated in this collection appears to celebrate the joy, the fervour, the terror of the actual moment of change. It uses the traditional features of the *ghazal* (the cup of wine, the 'gathering', the night of waiting) to speak about a very different kind of waiting:

> This surging revelry of pain
>> has reached tonight a frenzied peak
> hour after hour of waiting
>> glows in its own heat
>>>> (Poem 29)

Faiz, who died in 1984, was perhaps the last of the very great names. Fortunately, the *ghazal* appears to be in a healthy state in both India and Pakistan, and survives in a range of registers from the popular to the deeply serious. In India it has even come to be written in languages other than Urdu, in Gujarati for example, and in western India the word itself has cheerfully been taken over as '*gajal*'. There can be no greater sign of intimacy with the form than that.

The Question of Translation

Fortunately for those who aspire to translate poetry, it is generally accepted that the task is 'difficult'; and that in a certain sense it is impossible. When feeling particularly disheartened, we may even take refuge in Robert Frost's famously infamous remark that a translated poem is like a woman; it cannot be beautiful and faithful at

the same time. It is pertinent then to ask why one attempts to do it at all. A poem after all consists of infinitesimal combinations of word, assonance, suggestion, resonance, association, sound, rhythm, rhyme, music, speed...to reproduce it, you would need exactly the same combination of qualities in exactly the same relation to each other, in another language. In brief, this is not possible.

If one persists in attempting to 'translate', therefore, it is because of a belief that although one cannot reproduce the totality of a poem—the delicate balance of its elements—in another language, one can reproduce, or, more accurately, imitate, *some* of its elements; enough to give readers a glimpse into the possibilities of the original. There may be a striking image which would be as vivid in any language; a defiant thought which startles as much in translation as in the original; a brilliant coming together of abstract and concrete which can easily be carried over into the other language. It is for the translator to decide, line by line, which element, or elements, in each line are best worth transmitting, since an attempt to transmit them all would probably end up transmitting nothing. That the varying facets of a poem end up with a very different weightage in translation has been amply demonstrated by Aijaz Ahmed's experiment in the translating of Ghalib, cited earlier. Here, varied renderings by famous poets were astonishingly different. The point, however, is that they were also astonishingly beautiful; and finally, where does that beauty come from but from the original?

For obvious reasons the most difficult qualities to carry over in translation are those of sound—i.e. rhythm, metre and sound. Since the *ghazal* relies on precisely these to a large extent, the translator faces a loss from the start, and has to make choices about how to make this good. For myself, I decided that there was little point in attempting to stick to the couplet form in translation. Since the whole point of the couplets is the rhymes, and since those rhymes are not reproducible in English, to translate in couplets seemed needlessly pedantic. I have tried instead to recover the pleasure of the sound in other ways; using such rhyme patterns as presented

themselves, as well as repetition, alliteration, and differing fretworks in the metre.

When it comes to vocabulary, the problem is more familiar—in brief, that a word can do work in one language which its dictionary counterpart cannot do in another. A good example of the problems of literal translation is the famous first verse of Poem 7 by Zauq. The Urdu original is:

> *Layee hayaat aaye, qaza le chali, chale*
> *Apni khushi na aaye, na apni khushi chale*

Literally translated, this would be: 'Life brought us, we came, death takes us, we go. We did not come at our pleasure, we do not go at our pleasure.'

This literal rendering might well make the reader wonder why the poem is famous at all. What gives the couplet its beauty is the way the words of the original coalesce to create a rhythm which suggests a complete abandonment to something bigger, a sense of gliding back and forth entirely without a will of one's own, like a paper boat in the hands of a child. I could not convey this except by moving away from the literal and adding the image of following Death as it glides away.

I have allowed myself one liberty which is generally considered acceptable—which has indeed come to be expected—in renderings of the *ghazal*. That is, I have made my choice of couplets from each poem, and dropped ones which I think are less strong than the others. After all, this collection does not claim to be representative or comprehensive in any way. To use an image which is important to the *ghazal*, the poems are like slivers of a very personal mirror, scattered, but bright and shining.

At the end of it all, one can only 'crave the indulgence' of the reader. Those readers, especially, who love and revere the originals, will, I hope, be generous enough to make space for the different emphases and balances, and possibly the gaps of meaning, which here accompany my voice.

1 For this insight I am indebted to Ahmed Ali, *The Golden Tradition*, (New Delhi: Oxford University Press, 1992), p. 15.

2 It has now been more or less conclusively established that Wali Deccani came not from the Deccan, but from Gujarat. His tomb in Shahibaug, Ahmedabad, was demolished during the riots in 2002.

3 Since such ambiguity is impossible in English, in these poems '*woh*' has consistently been translated as 'she'.

4 Such reference to historical characters, and to Quranic *Ayats* and *Hadith* is known as *Talmih* and falls within the figures of speech used in Persian and Urdu literature.

5 For readers who are interested in pursuing a reading of Ghalib, I would recommend Ralph Russel's *The Famous Ghalib*, and Aijaz Ahmed's *Ghazals of Ghalib*. The latter is a particularly illuminating exercise in translation. The *ghazals* were first translated, word for word, the translation sticking like glue to the literal meaning. Subsequently these literal translations were given to seven famous American poets to be rendered into poetic form. The wide variation in the resulting poems is very revealing.

6 Ahmed Ali, *The Golden Tradition*, (New Delhi: Oxford University Press, 1992), p. 90.

Glimpses
of
the Ghazal

ا۔ درد

ارض و سما کہاں تری وسعت کو پا سکے
میرا ہی دل ہے وہ کہ جہاں تو سما سکے

وحدت میں تیری حرف دوئی کا نہ آ سکے
آئینہ کیا مجال تجھے منہ دکھا سکے

میں وہ فتادہ ہوں کہ بغیر از فنا مجھے
نقشِ قدم کی طرح نہ کوئی اٹھا سکے

قاصد نہیں یہ کام ترا اپنی راہ لے
اس کا پیام دل کے سوا کون لا سکے

یا رب یہ کیا طلسم ہے ادراک و فہم یاں
دوڑے ہزار آپ سے باہر نہ جا سکے

مستِ شرابِ عشق وہ بے خود ہے جب کو حشر
اے درد چاہیے لائے بخود، پھر نہ لا سکے

Howexpect
this tiny world
or heaven to
contain you?

Only my
elastic heart
can stretch enough
to claim you

Your oneness is
a flaming thing
no double
will it brook

Into that dazzling
Singleness
what mirror dares
to look?

I've sunk deep
as any footprint
which can never
hope to rise

till the last
Upheaval
tumbles
earth and sky

You who carry
notes and things
continue
on your path

The Message I
 await will be
delivered
 by the heart

This unholy
 snare, the mind
has cast a net
 around us

Flee though we may
 a hundred miles
the thought of self
 surrounds us

As for that wretch,
 who drinks the wine
of love, to lose
 his way

Nothing will
 restore his wits,
not even
 Judgement Day

Khwaja Mir Dard

۲۔ مومن

وہ جو ہم میں تم میں قرار تھا تمہیں یاد ہو کہ نہ یاد ہو
وہی یعنی وعدہ نباہ کا تمہیں یاد ہو کہ نہ یاد ہو

وہ جو لطف مجھ پہ تھے پیشتر وہ کرم کہ تھا مرے حال پر
مجھے سب ہے یاد ذرا ذرا تمہیں یاد ہو کہ نہ یاد ہو

وہ نئے گلے وہ شکایتیں وہ مزے مزے کی حکایتیں
وہ ہر اک بات پہ روٹھنا تمہیں یاد ہو کہ نہ یاد ہو

کوئی بات ایسی اگر ہوئی کہ تمہارے جی کو بری لگی
تو بیاں سے پہلے ہی بھولنا تمہیں یاد ہو کہ نہ یاد ہو

کبھی ہم میں تم میں بھی چاہ تھی کبھی ہم میں تم میں بھی راہ تھی
کبھی ہم بھی تم بھی تھے آشنا تمہیں یاد ہو کہ نہ یاد ہو

وہ گزرنا وصل کی رات کا وہ نہ مانا کسی بات کا
وہ نہیں نہیں کی ہر آن ادا تمہیں یاد ہو کہ نہ یاد ہو

جسے آپ گنتے تھے آشنا جسے آپ کہتے تھے باوفا
میں وہی ہوں مومنِ مبتلا تمہیں یاد ہو کہ نہ یاد ہو

The vow we made

with every breath
You may, you
may not remember

To love, that is,
unto the death
You may not
remember

How, like a gift
your smile at times
made of my pain
a shrine at times, how

might I not
remember?

Our endless feuds,
all make-believe
and new laments
for light relief

we never failed
to mock-bewail
the fate that gave
us each to each

and when for once
your woes were real
you thought of dire
words to hurl

but
you could not
remember

Well, there was once
 one heart between us
lay a pristine
 path between us

 once
if you could but
 remember

when every move
 met sweet rebuff
and no embrace
 was soft enough

No, no you pleaded
 ceaselessly
and let your eyes speak
 differently

That lover who
 possessed your soul
whom – when alone –
 you called your own

a world away
 from him who pleads
for mercy with
 your memories

I am that he.

 You may, you
may not remember.

Momin Khan Momin

۳- غَالِب

دائم پڑا ہوا ترے دَر پر نہیں ہوں میں
خاک ایسی زندگی پہ کہ پتھر نہیں ہوں میں؏

کیوں گردشِ مدام سے گھبرا نہ جائے دل
انسان ہوں پیالہ و ساغر نہیں ہوں میں

یا رب زمانہ مجھ کو مٹاتا ہے کس لیے؟
لوحِ جہاں پہ حرفِ مکرّر نہیں ہوں میں

حد چاہیے سزا میں عقوبت کے واسطے
آخر گنہگار ہوں کافر نہیں ہوں میں؏

Look I'm not
some kind of stone
 embedded in
your threshold

 If only I
could turn to dust
 since I
am no such stone

 And would it not
take fright, the heart
 at this perpetual
whirl?

 A human thing
It is, no
 cup that
revellers swirl

 Why is
the age determined
 to rub me off
the slate?

 Am I just
a letter that's
 repeated
by mistake?

 And why
must my chastisement
 continue
without end

When I
am but a sinner
no sort
of infidel?

Asadullah Khan Ghalib

۴۔ میر

اُلٹی ہوگئیں سب تدبیریں کچھ نہ دوا نے کام کیا
دیکھا اس بیماریِ دل نے آخر کام تمام کیا

عہدِ جوانی رو رو کاٹا پیری میں لیں آنکھیں موند
یعنی رات بہت تھے جاگے صبح ہوئی آرام کیا

ناحق ہم مجبوروں پر یہ تہمت ہے مختاری کی
چاہتے ہیں سو آپ کرے ہیں ہم کو عبث بدنام کیا

سارے رند اوباش جہاں کے تجھ سے سجدے میں رہتے ہیں
بانکے ٹیڑھے ترچھے تیکھے سب کا تجھ کو امام کیا

سرزد ہم سے بے ادبی تو وحشت میں بھی کم ہی ہوئی
کوسوں اس کے آگے پر سجدہ ہر ہر گام کیا

کس کا قبلہ کیسا کعبہ کون حرم ہے کیا احرام
کوچے کے اُس کے باشندوں نے سب کو یہیں سے سلام کیا

40

All hopes have been
 turned on their head
no cure has played its part

the illness in the
 heart is what
has done its work at last

My youth I spent
 in sighs and tears
in age, my eyes are closed

I mean I wept
 away the night
and now it's dawn
 I doze.

Unjustly you accuse
 us, God
of doing what we will

It's You who act
 on every whim
to us the ill name clings

All drunks and wastrels,
 scoundrels, rakes
their faith in You reveal

Those bent and twisted,
 broken, torn
without a murmur kneel

Though drunken, I
 forgot myself
and chased her steps with zeal

I behaved
 impeccably. At every
stage, I kneeled.

What Kaaba now?
 Which sacred site? What
shrine must we revere?

Those living in
 the street of love
make their salaams from here.

Mir Taqi Mir

۵۔ داغ

ساز یہ کینہ ساز کیا جائیں
ناز والے نیاز کیا جائیں

شمع رو آپ گو ہوئے لیکن
لطفِ سوز و گداز کیا جائیں

کب کسی در کی جبہ سائی کی؟
شیخ صاحب نماز کیا جائیں

جو رہِ عشق میں قدم رکھیں
وہ نشیب و فراز کیا جائیں

جن کو اپنی خبر نہیں اب تک
وہ مرے دل کا راز کیا جائیں

جو گزرتے ہیں داغ پر صدمے
آپ بندہ نواز کیا جائیں

You who play with
heart-strings
is there no tune
within?

You who burn
with beauty
Does no fire
enter in?

The sheikh who never
needs to bend
what does he
know of prayer?

Those who walk
the path of love
what do they
know of care?

Those who do not
know themselves
what can they
know of me?

You whose Mercy
binds us all
my breaking heart
how can you hope to see?

Nawab Mirza Khan Dagh Dehlvi

حالیؔ

ہے جستجو کہ خوب سے ہے خوب تر کہاں
اب دیکھیے ٹھہرتی ہے جا کر نظر کہاں

ہے دورِ جام اوّلِ شب میں جو دی گئی دور
ہوتی ہے آج دیکھیے ہم کو سحر کہاں

یا رب اس اختلاط کا انجام ہو نہ خیر
تھا اس کو ہم سے ربط مگر اس قدر کہاں

اک عمر چاہیے کہ گوارا ہو نیشِ عشق
رکھی ہے آج لذّتِ زخمِ جگر کہاں

بس ہو چکا کہ بیاں کسل و رنجِ راہ کا
غط کا مِرے جواب ہے اے نامہ بر کہاں

کون و مکاں سے ہے دلِ وحشی کنارہ گیر
اس خانماں خراب نے ڈھونڈا ہے گھر کہاں

حالیؔ نشاطِ نغمہ و مے ڈھونڈتے ہو اب
آئے ہو وقتِ صبح رہے رات بھر کہاں

We look for what is lovelier
 than loveliness
let's see where the eye alights

The first cup; I'm already
 far from self
let's see how the dawn arrives

God! I've loved before but not
 this way!
let's see what the end will be

Messenger, that's enough
 of your complaint.
Let's see the answer she sent me.

After an age, love's wound can be
 pleasantly scraped.
Let's see how long this one takes.

A heart laid waste remains where
 no soul stays
Let's see what home this one makes

Hali, it's morning and we see you looking for
 delight
Then why didn't you let us see you at night?

Khwaja Altaf Hussain Hali

۷۔ ذوق

لائی حیاتِ، آئے، قضا لے چلی چلے
اپنی خوشی نہ آئے نہ اپنی خوشی چلے

ہو عمرِ خضر بھی تو ہو معلوم وقتِ مرگ
ہم کیا رہے یہاں، ابھی آئے ابھی چلے

ہم سے بھی اس بساط پہ کم ہوں گے بد قمار
جو چال ہم چلے سو نہایت بری چلے

بہتر تو ہے یہی کہ نہ دنیا سے دل لگے
پر کیا کریں جو کام نہ بے دل لگی چلے

نازاں نہ ہو خرد پہ جو ہونا ہے، ہو وہی
دانش تیری نہ کچھ میری دانشوری چلے

دنیا نے کس کا راہِ فنا میں دیا ہے ساتھ
تم بھی چلے چلو یونہی جب تک چلی چلے

جاتے ہوائے شوق میں اس چمن سے ذوق
اپنی بلا سے بادِ صبا اب کبھی چلے

We follow life into the world
 because we are so told
Death glides noiselessly ahead
 and as we came, we go

And if it were a thousand years
 we were allowed to stay
We would break our hearts to think
 'We only came today'.

Well, there must be others in
 this world less skilled than Zauq;
Every move he makes but turns
 the board into a joke

Wiser far, perform the tasks
 of life without a heart
But when the heart is safe from harm
 for what life can you ask?

Of little use your wisdom here;
 my wit more useless still
What is to be, will be, while we
 declaim our fill.

And on this thorny path, when has
 the world been at your side?
Make what way you can, my friend;
 soon we'll be washed up by the tide.

I take leave of this garden now,
 on love's delirious breezes –
At last it is for me to say,
 let spring do as it pleases.

Sheikh Mohammed Ibrahim Zauq

۸۔ سودا

ٹوٹے تیری نگہ سے اگر دلِ حباب کا
پانی بھی پھر پیئں تو مزا ہے شراب کا

دوزخ مجھے قبول ہے اے مہر و نکیر
لیکن نہیں دماغ سوال و جواب کا

تھا کس کے دل کو کشمکشِ عشق کا دماغ
یارب بُرا ہو دیدۂ خانہ خراب کا

زاہد سبھی ہے نعمتِ حق جو ہے اکل و شرب
لیکن عجب مزا ہے شراب و کباب کا

قطرہ گرا تھا جو کے میرے اشکِ گرم سے
دریا میں ہے ہنوز پھپھولا حباب کا

سودا نگاہِ دیدۂ تحقیق کے حضور
جلوہ ہر ایک ذرّے میں ہے آفتاب کا

If your look
 can make
a bubble

burst outside
 its shine,
then water

can acquire
 with ease
the taste of wine.

Hell's okay
 with me,
you angels

divine,
 it's your
question-answer

sessions
 drive a man
out of his mind.

Did I ever
 volunteer
for the cut

and thrust
 of love?
A curse

upon the eyes
 which began
the wretched stuff –

You may be right,
O holy one,
in saying

that all
God's gifts
are blessed;

but wine and small
kebabs are still
a cut above

the rest –

Where, in
the stream
a hot

tear fell
from out my
brimming eyes

there will
you find
a sparkling

blister still
resides –
Sauda, for

the eye
which sees
there'll always

be a sun –
 waiting
to be found

in dust-specks,
 every one.

Mirza Mohamed Rafi Sauda

۹۔ اقبال

کبھی اے حقیقتِ منتظر نظر آ لباسِ مجاز میں
کہ ہزاروں سجدے تڑپ رہے ہیں مری جبینِ نیاز میں

طربِ آشنائے خروش ہو تو نوا ہے محرمِ گوش ہو
وہ سرود کیا کہ چھپا ہوا ہو سکوتِ پردۂ ساز میں

تو بچا بچا کے نہ رکھ اسے ترا آئینہ ہے وہ آئینہ
کہ شکستہ ہو تو عزیز تر ہے نگاہِ آئینہ ساز میں

نہ کہیں جہاں میں اماں ملی جو اماں ملی تو کہاں ملی
مرے جرمِ خانہ خراب کو ترے عفوِ بندہ نواز میں

جو میں سر بہ سجدہ ہوا کبھی تو زمیں سے آنے لگی صدا
ترا دل تو ہے صنم آشنا تجھے کیا ملے گا نماز میں

*E*very living hour
I pray – may You
 take mortal
shape. My bending
 forehead writhes
to touch the ground, a
 thousand
times obeisance make.

 With joy
release your voice
 for human
ear. You are all
 melody –
then whirl in here.
 Is there a tune
which does not burn
 to leave the lute?

 Don't enfold
or wrap or hold
 this glass of your
creating. It is a mirror
 meant to break –
the human heart you've made –
 each sliver dear
to the Mirror-Maker.

 I roamed
the world to find a home
 where sin like
mine was safe.
 The shelter
that I reached at last –
 Your All-
forgiving shade.

But when I
knelt, the ground was rent
by these
words of despair: You whose
heart
belongs to stone, what will*
you gain
from prayer?

Sheikh Mohammed Iqbal

* Literally, *sanam* or idol. The distasteful contemporary implications of terms like 'idol-worshipper' have made me change this to its more basic meaning.

۱۰۔ میرؔ

ابتدائے عشق ہے روتا ہے کیا
آگے آگے دیکھیے ہوتا ہے کیا

قافلے میں صبح کے اک شور ہے
یعنی غافل ہم چلے سوتا ہے کیا

سبز ہوتی ہی نہیں یہ سرزمیں
تخم خواہش دل میں تو بوتا ہے کیا

یہ نشانِ عشق ہاں میں جاتے نہیں
داغ چھاتی کے عبث دھوتا ہے کیا

غیرتِ یوسف ہے یہ وقتِ عزیز
میرؔ اس کو رائگاں کھوتا ہے کیا

58

This is but
> *the starting-*
out. And
> *you weep already?*

Awesome are
> *the storms ahead*
that love holds
> *at the ready.*

That clamour there –
> *a Caravan*
which leave at
> *dawn it must*

It mocks at
> *you, who Sleep –*
wheels thunder
> *through the dust.*

The valley of the heart
> *is bare: no*
green grows
> *in the heart*

Why then plant
> *the seed of wanting,*
and again
> *plant?*

The stains upon
> *the breast remain*
because the ink
> *is love*

By scrubbing what
 you hope to gain
is known to
 the Lord above

And while we're
 at it, Mir,
each hour
 burns

beautiful
 as Yusuf –
why let it
 slide, why must

it turn
 into
a wisp

of smoke?

<hr>

Mir Taqi Mir

۱۱ ۔ درد

تھمتیں چند اپنے دفینے دھر چلے
جس لیے آئے تھے ہم سو کر چلے

زندگی ہے یا کوئی طوفان ہے
ہم تو اس جینے کے ہاتھوں مر چلے

کیا ہمیں کام ان گلوں سے اے صبا
ایک دم آئے ادھر، اُودھر چلے

دوستو دیکھا تماشا یاں کا بس
تم رہو اب ہم تو اپنے گھر چلے

ایک میں دل ریش ہوں ویسا ہی دوست
زخم کتنوں کے سُنا ہے بھر چلے

شمع کے مانند ہم اِس بزم میں
چشم نم آئے تھے دامن تر چلے

ساقیا یاں لگ رہا ہے چل چلاؤ
جب تلک بس چل سکے ساغر چلے

درد کچھ معلوم ہے یہ لوگ سب
کس طرف سے آئے تھے کید ھر چلے

A heap of sins piled up, we leave.
What we
had come for, finally, achieved –

This whirlwind – is it really breath?
At any rate,
It grants to us the gift of death.

What use these flowers to us,
friend breeze?
We came a moment past, and must
take leave.

Friends, did you enjoy the show?
You stay
and watch, I'll seek my home.

What I carry is a wounded heart.
Has it
been known to heal, that kind of Dart?

On entering the room, we're
dew-eyed, candle-like
We leave with gutted hems, when
snuffed out by life

The cup still doing the rounds and there's
a bustle to Depart
Bear it as you did before –
If you have the heart.

Any notion, Dard, about the wanderings
of these folk?
From which door they came, and to
which door they go?

Khwaja Mir Dard

اثر اس کو ذرا نہیں ہوتا
رنج راحت فزا نہیں ہوتا

بے وفا کہنے کی شکایت ہے
تو بھی وعدہ وفا نہیں ہوتا

تم ہمارے کسی طرح نہ ہوئے
ورنہ دنیا میں کیا نہیں ہوتا

اُس نے کیا کیا جانے کیا کیا لے کر
دلِ کسی کام کا نہیں ہوتا

تم مرے پاس ہوتے ہو گویا
جب کوئی دوسرا نہیں ہوتا

حال دلِ یار کو لکھوں کیونکر
ہاتھ دل سے جدا نہیں ہوتا

کیوں سنے عرض مضطر اے مومن
صنم آخر خدا نہیں ہوتا٭

She will not change her ways. All
my pain brings me no profit.

Will not hear that she is faithless
And all the while she keeps no promise.

If only I could have you
beyond belief there would be nothing

But what was it you did which
left my heart good for nothing?

When I am truly on my own
you never leave my thought

How write of this to you? This hand
of mine won't leave my heart

After all, why should she listen
Momin, you whimpering sod?

It's not for her to cure all grief.
A mistress is not God.

Momin Khan Momin

۱۳۔ داغ

سبق ایسا پڑھا دیا تونے
دل سے سب کچھ بھلا دیا تونے

ہم نکمّے ہوئے زمانے کے
کام ایسا سکھا دیا تونے

کچھ تعلّق رہا نہ دنیا سے
شغل ایسا بتا دیا تونے

کس خوشی کی خبر سنا کے مجھے
غم کا پُتلا بنا دیا تونے

لاکھ دینے کا ایک دینا ہے
دلِ بے مُدّعا دیا تونے

کیا بتاؤں کہ کیا کیا میں نے
کیا کہوں میں کہ کیا دیا تونے

بے طلب جو ملا ملا مجھ کو
بے غرض جو دیا دیا تونے

شبِ تیرہ میں شمع روشن کو
نورِ خورشید کا دیا تو نے

کہیں مشتاق سے حجاب ہوا
کہیں پردہ اٹھا دیا تو نے

مٹ گئے دل سے نقشِ باطل سب
نقشہ ایسا جما دیا تو نے

مجھ گنہگار کو جو بخش دیا
تو جہنم کو کیا دیا تو نے

You made me Recite a
 lesson
drove all knowledge from my heart

unstitched me from the world
unskilled me from my craft

You set me to a
 Work, which
answers no-one's needs

Brought me news of happiness
which is the same as grief.

Your countless gifts are in
 this gift
You spared for me a loving heart

to tell you what your giving is –
this is not for my poor art

the giving which draws down
 the sun
into the candle's flame

which hides from devotees
and then, sometimes, Unveils

The table of my heart
 Is cleaned
of every smudge and stain

Only what you Stamped on it
deep-cut and clear, remains

A question, too, remains
 with me
if you should choose to tell

when sin like mine is pardoned
do any go to hell?

Nawab Mirza Khan Dagh Dehlvi

۱۴۔ حالی

درد دل کو دوا سے کیا مطلب
کیمیا کو طلا سے کیا مطلب

چشمہِ زندگی ہے فکرِ جمیل
خضر و آبِ بقا سے کیا مطلب

بادشاہی ہے نفس کی تسخیر
ظلِ بالِ ہما سے کیا مطلب

ہے اگر دند دامن آلودہ
ہم کو پون و چرا سے کیا مطلب

صوفئ شہر با صفا ہے اگر وہ
ہو ہماری بلا سے کیا مطلب

نکہتِ سمع پہ غش ہیں جو حالی
ان کو درد و صفا سے کیا مطلب

As the ache
 in the heart
has no use for cures

and the seeker
 in alchemy,
no use for pure

gold —

so to wonder
 at beauty
is the spring-source

we live for
 even when life
eternal's on offer

The only
 real conquest:
subduing desire

To vanquish
 the phoenix needs
no sort of power

If the drunk has
 a garment that's
covered with smears

and the Sufi
 a conscience
that's crystal-clear

why need it
 concern us
here –

And if one whiff
 can make
some swoon

of what
 use is
a brimming

bowl?

Khwaja Altaf Hussain Hali

۱۵۔ غالِب

یہ نہ تھی ہماری قسمت کہ وصالِ یار ہوتا
اگر اور جیتے رہتے یہی انتظار ہوتا

ترے وعدہ پر جیے ہم تو یہ جان جھوٹ جانا
کہ خوشی سے مر نہ جاتے اگر اعتبار ہوتا

رگِ سنگ سے نکلتا وہ لہو کہ پھر نہ تھمتا
جسے غم سمجھ رہے ہو یہ اگر شرار ہوتا

کوئی مرے دل سے پوچھے ترے تیرِ نیم کش کو
یہ خلش کہاں سے ہوتی جو جگر کے پار ہوتا

اسے کون دیکھ سکتا کہ یگانہ ہے وہ یکتا
جو دوئی کی بو بھی ہوتی تو کہیں دو چار ہوتا

یہ مسائلِ تصوف یہ ترا بیان غالِب
تجھے ہم ولی سمجھتے جو نہ بادہ خوار ہوتا

74

To meet the one I seek: this was not
 written in the skies
It would have been a longer wait, had I
 lived a longer life

If I lived upon your promise, it was still
 without belief
would not my heart have burst, had such
 joy been received?

Those tender veins in stone would have gushed
 unending blood
If what you think is grief, had any flint
 inside its gut

My heart alone is proof that your arrow
 was half-drawn
what would be left to wound, had it done
 the slightest harm?

Can any see that figure, which is Single
 through and through?
Would it not have walked among us, had it
 held a hint of Two?

These mystical reflections, these wise
 pronouncements, Ghalib!
You'd have been proclaimed The Wise, had you been
 less fond of wine.

Asadullah Khan Ghalib

۱۷۔ ذوق

کسی بیکس کو اے بیدادگر مارا تو کیا مارا
جو خود ہی مر رہا ہے اسکو گر مارا تو کیا مارا

بڑے موذی کو مارا نفسِ امارہ کو گر مارا
نہنگ و اژدہا و شیرِ نر مارا تو کیا مارا

نہ مارا آپ کو جو خاک ہو اکسیر بن جانا
اگر پارے کو اے اکسیر گر مارا تو کیا مارا

تفنگ و تیر و ظاہر تھا نہ کچھ تھا پاس قاتل کے
الٰہی پھر جو دل پر تاک کر مارا تو کیا مارا

مرے آنسو ہمیشہ میں برنگ لعل شوقِ خوں
جو غوطہ آب میں تو نے گہر مارا تو کیا مارا

If the wretch
 your glance dispatched
had no life left
 what did you kill?

If you just mixed,
 friend alchemist
elixir-dust
 what is your skill?

If the dust
 was not of Self *
what is it
 you call gold?

If you can kill
 All beasts but Lust
what then is
 your boast?

If she had
 no quiver near
 – that piercing dart
what was it?

My tears are ruby,
 drowned in blood.
If every pearl
 can plumb the sea

what of it?

Sheikh Mohammed Ibrahim Zauq

* Refers to the belief that the 'philosopher's stone' is actually the ego ground to dust. See alternative translation by Ahmed Ali, *The Golden Tradition*, p. 210.

ولی

اس کوں حاصل کیوں کر ہو جگ میں فراغِ زندگی
گردشِ افلاک ہے جس کوں ایاغِ زندگی

اے عزیزاں سیرِ گلشن ہے گلِ داغِ الم!
صحبتِ احباب ہے معنی میں باغِ زندگی

لب میں تیرے فی الحقیقت چشمۂ آبِ حیات
خضرِ خط نے اس سوں پایا ہے سراغِ زندگی

جب سوں دیکھائیں نظر بھر کاکلِ مشکیں پیار
تب سوں بوں سنبل پریشاں ہے دماغِ زندگی

آسماں میری نظر میں قبۂ تاریک ہے
گر نہ دیکھوں تجھ کوں اے چشم و چراغِ زندگی

Time swirls by and slops your share
 into the Cup of life
How can you then in peace
 sup of life?

This garden of bewitching scents
 gifts only stains
The fragrant smell of friendship
 alone remains

Within your lips, the spring
 which waters all
makes of your face a garden
 sought by all

Like a thistle, back and forth
 flies my mind
Only on her flowing hair
 will it alight

The sky becomes a darkened cave
 without the sight
of You, who give us all we have
 of light.

Wali Mohammad Wali

۱۸۔ اِنشاء

کمر باندھے ہوئے ہوئے چلنے پہ یاں سب یار بیٹھے ہیں
بہت آگے گئے، باقی جو ہیں تیار بیٹھے ہیں

نہ چھیڑ اے نکہتِ بادِ بہاری، راہ لگ اپنی
تجھے اٹکھیلیاں سوجھی ہیں، ہم بیزار بیٹھے ہیں

خیال ان کا پرے ہے عرشِ اعظم سے کہیں ساقی
غرض کچھ اور دِن میں اس گھڑی مینخوار بیٹھے ہیں

لسانِ نقش پا ہائے رہروانٔ کوئے تمنّا ہیں
نہیں اٹھنے کی طاقت، کیا کریں لاچار بیٹھے ہیں

یہ اپنی چال ہے افتادگی سے ان دنوں بہروں
نظر آیا جہاں پر سایۂ دیوار بیٹھے ہیں

کہیں بوسے کی مت جرأت دلا کر بیٹھیو ان سے
ابھی اس حد کو وہ کیفی نہیں، ہشیار بیٹھے ہیں

نئی یہ وضع شرمانے کی سیکھی آج ہے تم نے

ہمارے پاس صاحب ورنہ یوں سوبار بیٹھے ہیں۔

بھلا گردش فلک کی چین دیتی ہے کسے انشاء

غنیمت ہے کہ ہم صورت یہاں دو چار بیٹھے ہیں

*T*heir waist-bands tightly tied, they wait
 tautly for the stir
Some have left already, the rest
 are ready here

Don't tease me, scented breeze! My life
 is in the sere
You may frisk and spin, I'm only
 good for sitting here

You bear the cup to every one, but they
 are nowhere near
They've sailed past several heavens, all
 while sipping here

I'm a footprint that's forgotten in the
 lane called desire
so sunken in its mud that
 I'm still stiffening here

This is my state, that if I find
 a shady wall is near
At any hour you might exclaim
 'Again prostrated here!'

It's not yet time, my heart, to try
 and set aside your fear
She's not yet drunk, will know she's kissed
 though reclining here

A new ploy this, to imitate
 the shyness of a deer!
A hundred times I've gazed like this
 you remaining here

When did the heavens bring us peace
 revolving round each sphere?
The mercy is, we friends, we few
 are together here.

Insha Allah Khan Insha

۱۹۔ درد

تجھ کو جویاں جلوہ فرما نہ دیکھا
برابر ہے دنیا کو دیکھا نہ دیکھا

مرا غنچہء دل ہے وہ دلِ گرفتہ
کہ جس کو کسی نے کبھی وا نہ دیکھا

اذیّت، مصیبت، ملامت، بلائیں
ترے عشق میں ہم نے کیا کیا نہ دیکھا

کیا مجھ کو داغوں نے سدِ چراغاں
کبھو تو نے آ کر تماشا نہ دیکھا

حجاب رخِ یار تھے آپ ہی ہم
کھلی آنکھ جب، کوئی پردہ نہ دیکھا

شب و روز لے درد در پہ ہوں اُن کے
کسو نے جسے یاں نہ سمجھا نہ دیکھا

84

If your Glow itself remains unseen
What remains is all the same: seen, unseen

My heart a bud already dried
A bloom whose bloom was never seen

Torment, despair, rebuke, disaster –
For the love of God what haven't I seen?

Like fireworks my wounds ablaze
One entertainment that you've never seen

The veil that hid my love – it was myself.
When I awoke at last, no veil was seen

Day and night, Dard, I try to see
Him who has never been known or seen.

Khwaja Mir Dard

۲۰۔ غالب

دلِ ناداں تجھے ہوا کیا ہے؟
آخر اس درد کی دوا کیا ہے؟

ہم ہیں مشتاق اور وہ بیزار
یا الٰہی یہ ماجرا کیا ہے؟

میں بھی منہ میں زبان رکھتا ہوں
کاش پوچھو کہ مدعا کیا ہے؟

جب کہ تجھ بن نہیں کوئی موجود
پھر یہ ہنگامہ اے خدا کیا ہے؟

سبزہ و گُل کہاں سے آئے ہیں؟
ابر کیا چیز ہے؟ ہوا کیا ہے؟

ہم کو اُن سے وفا کی ہے امید
جو نہیں جانتے وفا کیا ہے؟

جان تم پر نثار کرتا ہوں
میں نہیں جانتا دعا کیا ہے؟

میں نے مانا کہ کچھ نہیں غالبؔ
مفت ہاتھ آئے تو بُرا کیا ہے؟

My foolish heart,
 what is it?
If there's a cure,
 what is it?

I'm on fire,
 she's plain bored.
This frenzied whirl,
 what is it?

It happens I
 possess a tongue.
If she would ask,
 What is it?'

We know that You
 are all there is
Then all of this,
 what is it?

Where did the trees,
 the flower come from?
And the wind,
 what is it?

We long for faith
 from her who says
of faithfulness,
 What is it?'

For you, I'll sacrifice
 my life.
But as for prayer,
 what is it?

Worthless though
 he be, Ghalib
came for free.
 So your complaint,

what is it?

Asadullah Khan Ghalib

۲۱ ـ حالیؔ

کوئی محرم نہیں ملتا جہاں میں
مجھے کہنا ہے کچھ اپنی زباں میں

قفس میں جی نہیں لگتا کسی طرح
لگا دو آگ کوئی آشیاں میں

کوئی دن بولہوں بھی شاد ہولیں
دھرا کیا ہے اشاراتِ نہاں میں

کہیں انجام آ پہنچا وفا کا
کھلا جاتا ہوں اب کے امتحاں میں

دلِ پُر درد سے کچھ کام لونگا
اگر فرصت ملی مجھ کو جہاں میں

بہت ہی خوش ہوا حالیؔ سے مل کر
ابھی کچھ لوگ باقی ہیں جہاں میں

90

There's no listener for my
secret griefs
I need a tongue that's
all my own

Go burn my nest
that I may come
to love the cage in
which I lie alone

Well, then, let them rejoice,
my rivals!
What, in those signs
of hers, was shown?

The end of faithfulness
has come. . .
Her questioning which
makes all known.

I'll put my pain to
use in love
If there be time before
my turn is gone

Meeting Hali: it was
pure delight.
The world still has
good souls, I own.

Khwaja Altaf Hussain Hali

۲۲- سراج اورنگ آبادی

خبر تحیرِ عشق سن، نہ جنوں رہا نہ پری رہی
نہ تو رہا نہ میں رہا، جو رہی سو بے خبری رہی

شہِ بے خودی نے عطا کیا مجھے اب لباسِ برہنگی
نہ خرد کی بخیہ گری رہی نہ جنوں کی پردہ دری رہی

چلی سمتِ غیب سیں کیا ہوا کہ چمن ظہور کا جل گیا
مگر ایک شاخِ نہالِ غم جسے دل کہوں سو ہری رہی

وہ عجب گھڑی تھی میں جس گھڑی لیا درس نسخہء عشق کا
کہ کتاب عقل کی طاق میں جوں دھری تھی تیوں ہی دھری رہی

کیا خاک آتشِ عشق نے دلِ بے نوائے سراج کوں
نہ خطر رہا نہ حذر رہا مگر ایک بے خطری رہی

The thing called love: they brought me news
 All frenzy went, and fairy form
And neither I, nor you remained –
 And Unremaining filled the room.

The Lord who peels away the self
 gave me the cloth of nakedness
All that wisdom stitched was gone
 the veil which covers madness, torn.

And what came from behind all sight
 To burn the Garden of the Seen?
On the tree of life, one twig –
 the heart, they call it – is still green.

A stolen hour! I chanced upon
 The Recipe called love
From that o'clock, the Book of Sense
 stayed on the shelf above.

My heart is done with smouldering
 Siraj, the end is here –
How light a thing, this heap of ash
 no longer tied to fear.

 Siraj Aurangabadi

۲۳- داغ

جلوے مری نگاہ میں کون و مکاں کے ہیں
مجھ سے کہاں چھپیں گے وہ ایسے کہاں کے ہیں

کرتے ہیں قتل وہ طلبِ مغفرت کے بعد
ہوتے ہیں دعا کے ہاتھ وہی امتحاں کے ہیں

جس دن سے کچھ شریک ہوئی میری مشتِ خاک
اس روز سے زمیں پہ ستم آسماں کے ہیں

عاشق تیرے عدم کو گئے کس کس قدر تباہ
پوچھا ہے اک نے یہ مسافر کہاں کے ہیں؟

All that is inside the globe
 comes within my sight –
What is his magic country
 allows him still to hide?

He asks for my forgiveness
 and after, strikes me dead
The hand raised in devotion
 is also raised in threat –

This pinch of dust was joined
 to all that lives on earth
and then the skies descended
 in unrelenting wrath –

Love's victims reached the other world
 – so wretched was their plight
Bystanders said, 'Good heaven!
 From which hell.did they take flight?'

Nawab Mirza Khan Dagh Dehlvi

۲۴- اکبر الہ آبادی

دُنیا میں ہوں، دنیا کا طلب گار نہیں ہوں
بازار سے گزرا ہوں، خریدار نہیں ہوں

زندہ ہوں مگر زیست کی لذت نہیں باقی
ہر چند کہ ہوں ہوش میں، ہشیار نہیں ہوں

اس خانۂ مستی سے گزر جاؤں گا بے ہوش
سایہ ہوں فقط، نقش بہ دیوار نہیں ہوں

وہ گُل ہوں، خزاں نے جسے برباد کیا ہے
الجھوں کسی دامن سے، یہ وہ خار نہیں ہوں

گو دعویِ تقویٰ نہیں، درگاہِ خدا میں
بُت جس سے ہوں خوش ایسا صنم کار نہیں ہوں

افسردگی و ضعف کی کچھ حد نہیں اکبر
کافر کے مقابل میں بھی دیں دار نہیں ہوں

In this glowing
 market
I have no will
 to buy

will go from all
 that teems
without touching,
 being touched by.

I am sensible
 of life
and have no sense
 I live

not a painting
 that will last
just a shadow
 made to shift

a flower
 shrunk and worn
not a living,
 plucking thorn.

I'll cut a sorry
 figure
when I reach
 the final Court

nor yet am such
 a sinner
as to win
 my idol's heart

A single drop
 of faith or hope
would give me some
 relief

By my side,
 an atheist
is happy in
 belief

Akbar Hussain Akbar Allahabadi

۲۵- فِراق

آج بھی قافلۂ عشق رواں ہے کہ جو تھا
وہی میل اور وہی سنگِ نشاں ہے کہ جو تھا

آج بھی عشق لٹانا دل و جاں ہے کہ جو تھا
آج بھی حُسن وہی جِنس گراں ہے کہ جو تھا

دلِ سوزاں سے ہے پُر نُور شبستانِ وجود
عشق پھر شمع محراب جہاں ہے کہ جو تھا

منزلیں عشق کی تاحدِّ نظر سُونی ہیں
کوئی رہرو یہاں ہے نہ وہاں ہے کہ جو تھا

ظلمت و نُور میں کچھ بھی نہ محبّت میں ملا
آج تک دھند لکے کا سماں ہے کہ جو تھا

100

The caravan of love,
 as always
on the road

Again the same
 old mile, again
the same milestone

Again are heart
 and soul
waylaid as they go

As ever, beauty's
 treasure chest
is the cause of woe

And when a flare
 is needed
for the night of life

It is the flaming
 heart alone
that light provides

On love's high road as
 always, no
wayfarer in sight

as love fails
 in the daytime,
so it fails at night

the world of love
 remains as
ever, in twilight.

Raghupati Sahai Firaq

۲۶۔ حسرت

گھر کے آخر آج برسی ہے گھٹا برسات کی
میکدوں میں کب سے ہوتی تھی دعا برسات کی

موجبِ سوز و سرور و باعثِ عیش و نشاط
تازگی بخش دل و جاں ہے ہوا برسات کی

شام سرما دلربا تھا، صبح گرما خوش نما
دلرُبا تر، خوشنما تر، ہے فضا برسات کی

سُرخ پوشش پر ہے زرد و سبز بوٹوں کی بہار
کیوں نہ ہوں رنگینیاں تجھ پر فدا برسات کی

دیکھنے والے ہوئے جاتے ہیں پامال ہوس
دیکھ کہ چھب تیری اے رنگیں ادا برسات کی

The skies
 have crashed
together, flung
 their waters
to the earth

How the taverns
 prayed for
just such
 lifting
of the thirst!

The night
 becomes
delirium,
 the air turns
into wine

Winter nights
 and summer
dawns,
 -are in the heart
entwined

And you
 in sunset
colours,
 wreathed in
tiny silken flowers

which
 the gleaming
rainshine
 caresses
by the hour —

while those
 condemned
by Fate
 to glimpse
your rain-drenched

face
 can only pray
and pray again
 to turn to
drops of rain.

Maulana Fazal-ul-Hasan Hasrat Mohani

۷۲۔ اقبال

خرد مندوں سے کیا پوچھوں کہ میری ابتدا کیا ہے
کہ میں اس فکر میں رہتا ہوں میری انتہا کیا ہے

خودی کو کر بلند اتنا کہ ہر تقدیر سے پہلے
خدا بندے سے خود پوچھے بتا تیری رضا کیا ہے

مقام گفتگو کیا ہے اگر میں کیمیا گر ہوں
یہی سوزِ نفس ہے اور میری کیمیا کیا ہے

نظر آئیں مجھے تقدیر کی گہرائیاں اس میں
نہ پوچھ اے ہم نشیں مجھ سے وہ چشم سرمہ سا کیا ہے

نوائے صبح گاہی نے جگر خوں کر دیا میرا
خدایا جس خطا کی یہ سزا ہے وہ خطا کیا ہے

How would it help it to ask the wise
 What my Beginning was
When the fear within me says,
 'My end, what will it be?'

Make selfhood so unquestioned
 That when allotting fate
The Lord's Himself constrained to say
 'Your life – what shall it be?'

Is there need for wonder
 If I lay claim to alchemy
– other than this burning
breath, what would it be?

In their depths I read my fate:
 deep lakes lined with kohl.
Don't ask, I beg, about them now,
 'These lakes, what would they be?'

At dawn the call to prayer
 turns my heart to stone –
the crime for which such fear atones –
 that crime, what could it be?

Sheikh Mohammad Iqbal

۴۸- ساحِر لُدھیانوی

تنگ آچُکے میں کشمکشِ زندگی سے ہم
ٹھکرا نہ دیں جہاں کو کہیں بے دِلی سے ہم

لو آج ہم نے توڑ دیا رشتۂ اُمید
لو اب کبھی گلہ نہ کریں گے کسی سے ہم

اُبھریں گے ایک بار ابھی دِل کے وَلولے
گو دب گئے ہیں بارِ غم زندگی سے ہم

گر زندگی میں مِل گئے ہم اتفاق سے
پوچھیں گے اپنا حال تِری بے بسی سے ہم

اللہ رے فریبِ مشیت کہ آج تک!
دُنیا کے ظلم سہتے رہے خامشی سے ہم

This fretful
 world, this weary
swirl of words.
 If I should
hurl away
 the whole?

The deadened
 heart,
the empty breath
 of love denied.
All things hateful
 to the eye.

Look, here I
 break
the thread of
 hope.
Now I'll make
 no more complaint.

The whirling
 pool
swells in my breast
 again.
I thought all
 that was drowned

by pain.
 If we meet
somewhere
 by chance
I'll learn of
 my state from

your broken heart.
 You and I,
we're hypnotised.
 Do we ask
the great
 performer, Fate,

to explain the game?

Abdul Haie Sahir Ludhianvi

۲۹ ـ فیض

آج یوں موجِ درِ موجِ غم تھم گیا، اس طرح غم گزیدوں کو قرار آگیا
جیسے خوشبوۓ زلفِ بہار آگئی، جیسے پیغامِ دیدارِ یار آگیا

جس کی دید و طلب وہم سمجھے تھے ہم، رو بہ رو پھر سرِ راہ گزار آگیا
صبحِ فردا کو پھر دل ترسنے لگا، عمرِ رفتہ تِرا اعتبار آگیا

رُت بدلنے لگی رنگِ دل دیکھنا، رنگِ گلشن سے اب حال کھلتا نہیں
زخم چھلکا کوئی یا کوئی گل کھلا، اشک اُمڈے کہ ابرِ بہار آگیا

خونِ عشاق سے جام بھرنے لگے، دل سلگنے لگے داغ جلنے لگے
محفلِ درد پھر رنگ پر آگئی، پھر شبِ آرزو پر نکھار آگیا

سرفروشی کے انداز بدلے گئے، دعوتِ قتل پر مقتلِ شہر میں
ڈال کر کوئی گردن میں طوق آگیا، لا دکر کوئی کاندھے پہ دار آگیا

فیض کیا جانیے یار کس آس پر، منتظر ہیں کہ لائے گا کوئی خبر
مے کشوں پر ہوا محتسب مہرباں، دلفگاروں پہ قاتل کو پیار آگیا

112

*T*oday,

Wave on wave of grief is still
 and calm as any sea
like the scent of breeze-blown spring
 like word from one you long to see

My desire seemed a frenzied dream
 but on my path his form appears
Again I wait for dawn to come,
 have faith that yesterday was here.

The season turns, now view my heart:
 flowers won't show what's within –
a wound just burst, a thrusting bud,
 a tear welled up, or some such thing –

What pours into our cups today
 is blood of those who fiercely loved
Hearts will start to smoulder now
 it's now that scars begin to burn

This surging revelry of pain
 has reached tonight a frenzied peak
hour after hour of waiting
 glows in its own heat

New martyrdoms are sought:
 where the gallows stand
they come with halters round the throat
 or crosses in the hand

What breeze is it that makes me scent
 a coming time of hope?
When moralists will smile on wine, cruel
 ones caress the hearts they broke?

Faiz Ahmed Faiz

۳۰۔ غالبؔ

مُشکل ہے زبس کلام میرا اے دل
سُن سُن کے اُسے سخنورانِ کامل

آساں کہنے کی کرتے ہیں فرمائش
گویم مُشکل وگرنہ گویم مُشکل

Well, my heart,
 my verse is tough!
Those who descant
 on such things, say
Enough. How can that
 be verse which is
not understood by us?

And I reply,
 my verse is hard
indeed.
 If I did not,
It would go hard
 with me, my heart!

Asadullah Khan Ghalib

Note: This is the only poem in the collection which is not a *ghazal* but a *rubai*, or quatrain. I thought it would be fun to end with it as it contains a cheeky complaint by the greatest of these poets against—all of us.

Biographical Notes on the Poets (in chronological order)

Wali
Wali Mohammad Wali, or Wali Deccani, as he was popularly known (1667–1707)
Wali is thought by some to have been born in Aurangabad in the Deccan and is one of the greatest 'Deccani' poets. Others maintain that he actually hailed from Gujarat. What is certain is that he spent many years in Ahmedabad, where he lies buried. According to many, it was Wali's visit to Delhi in 1707 which led to a crucial merging of Deccani and northern Urdu, and marked the beginning of the classical *ghazal*.

Sauda
Mirza Mohamed Rafi Sauda (1713–1781)
Born in Delhi and belonged to the Delhi School although the social and political instability which followed the sacking of Delhi by Nadir Shah finally compelled him to migrate to Lucknow. Celebrated more for satire than for lyricism.

Siraj
Siraj Aurangabadi (1715–1763)
Born in Aurangabad, Maharashtra. Is said to have experienced a state of mystic frenzy at a young age, which lasted for seven years. He wrote *ghazals*, *qasidas*, *rubais*, etc. but finally gave up writing, and at the end of his life he renounced the world.

Dard
Khwaja Mir Dard (1720–1784)
One of the poets of the Delhi School along with Sauda and Mir. Like Siraj, he was a genuine mystic whose real life appeared to lie outside the material world. After the sack of Delhi he did not, unlike his peers move to Lucknow, but stayed on, gaining faith from his Sufi tenets. His best poetry combines secular and spiritual love.

Mir
Mir Taqi Mir (1722–1808)
Born in Agra. Financial and family troubles early in life drove him insane, but after recovering he began to establish himself in Delhi as one of the greatest composers of the *ghazal* ever. He too left Delhi for Lucknow but was never reconciled to the change. Of all *ghazal* writers he is perhaps the most deeply sensitive to love and its

pain. His last years were lonely and unhappy, marred by the death of near ones, but he continued writing to the end.

Insha
Insha Allah Khan Insha (1752–1818)
Born in Murshidabad in Bengal but moved to Delhi and Lucknow. Known for his sense of fun, his romantic poems are enjoyable rather than intense. His last days were marked by tragedy; possibly the reason for the weariness and longing for release which characterise the famous *ghazal* included here.

Zauq
Sheikh Mohammed Ibrahim Zauq (1788–1855)
Born in Delhi to a relatively humble family. Later, however, he became close to the royal family and became the *ustad* of the king Bahadur Shah Zafar. His weighty style is usually considered more successful in forms other than the *ghazal*.

Ghalib
Asadullah Khan Ghalib (1797–1869)
Born in Agra. The loss of his father at a very young age was only the first of the shattering tragedies which marked his life—including the loss of all his seven children. These tragedies were compounded by financial troubles and the fruitless pursuit of a pension from the British goverment. The horrors which followed the Revolt of 1857 scarred him for life. However, he never lost his love of life, his ebullience, his ardour, his brilliant wit and his subtle imagination. The vast canvas of his poetry covered every possible state of mind—including the simple passion of love.

Momin
Momin Khan Momin (1801–1852)
Like Zauq and Ghalib, belonged to the 'second Delhi School', at the time of Bahadur Shah Zafar. Unlike many of the poets represented here, he was economically secure all his life, coming as he did from a family of well-known physicians. He was frankly a poet of physical love. His *ghazals* are marked by an unusual continuity of theme.

Dagh
Nawab Mirza Khan Dagh Dehlvi (1831–1905)
Born in Delhi. Through his mother's remarriage he became a part of the

extended royal household of Bahadur Shah Zafar, and had the advantage of closeness to Ghalib and Zauq. The Revolt forced him to move to the court of Rampur for the latter part of his life. His poetry was felicitous and accessible rather than intense.

Hali
Khwaja Altaf Hussain Hali (1837–1914)
Born in relative poverty in Punjab. He was a government servant with the British government and later a teacher in the Anglo-Arabic College in Delhi. His poetry tends to be a vehicle for social and moral ideas, as witness his famous long poem *Musaddas*.

Akbar Allahabadi
Akbar Hussain Akbar Allahabadi (1846–1921)
Born near Allahabad. Was a lawyer in government service with the British government. Was familiar enough with Western life to champion 'Eastern' values over Western ones—according to him, love and faith rather than reason and logic. He used English words in his poetry with ease, and in one quatrain he claimed an affinity with Spenser the poet rather than Mill the philosopher.

Iqbal
Sheikh Mohammad Iqbal (1873–1938)
Born to a middle-class family in Sialkot, Punjab. Studied philosophy and law at Cambridge, continued legal practice all his life. Became an important thinker and reformer for the Muslim community, and was an early advocate of the idea of Pakistan. His poetry tends to the didactic and the rhetorical.

Hasrat Mohani
Maulana Fazal-ul-Hasan Hasrat Mohani (1875–1951)
He was born in Mohan at Uttar Pradesh, and educated at Aligarh. He became a passionate and radical participant in the national freedom movement, first with the Indian National Congress and then with the Muslim League. He combined journalism with his political work, but still managed to write over 700 *ghazals*.

Firaq
Raghupati Sahai Firaq (1896–1982)
Born in Gorakhpur, Uttar Pradesh. Joined government service with the British Government, then became a famous teacher of English literature at the University of Allahabad. His poetry is delicately sensuous. It is given body not

just by his familiarity with Western literature, but more importantly, by his knowledge of the Hindi and Sanskrit poetic tradition. This gives a beautifully indigenous tinge to his poems.

Faiz
Faiz Ahmed Faiz (1911–1984)
Born in Sialkot in the Punjab. Became a journalist and political activist against the Raj. Not surprisingly the romanticism of the *ghazal* gave way, in his poetry, to socialist and revolutionary ideas for which the traditional idiom was superbly transmuted. Considered one of the greatest Urdu poets of the 20th century, and although he remained a Pakistani citizen he was deeply loved and honoured in India.

Sahir Ludhianvi
Abdul Haie Sahir Ludhianvi (1922–1980)
Born in a feudal family near Ludhiana, but educated himself away from feudal values. His early poetry, which displayed socialist sympathies, was an instant success. Later he moved to Mumbai and began a career writing lyrics for films. These beautiful lyrics have made him one of the best-loved of the writers of film songs.

Bibliography

Ahmed, Aijaz, ed. *Ghazals of Ghalib*. New Delhi: Oxford University Press, 1994

Ali, Ahmed. *The Golden Tradition: An Anthology of Urdu Poetry*. New Delhi: Oxford University Press, 1992

Issar, T.P. *Ghalib: Cullings from the Divan*, rendered in English. Bangalore: T.P. Issar, 1999

Kanda, K.C. *An Anthology of the Urdu Ghazal from the 16th to the 20th Century*. New Delhi: Sterling Publishers, 1994

Kanda, K.C. *Masterpieces of the Urdu Ghazal from the 17th to the 20th Century*. New Delhi: Sterling Publishers, 1990

Matthews, D.J. and Shackle, C. *An Anthology of Classical Urdu Love Lyrics*. New Delhi: Oxford University Press, 1972

Russell, Ralph, ed. *Ghalib: The Poet and His Age*. New Delhi: Oxford University Press, 1997

Russell, Ralph. *The Famous Ghalib*. New Delhi: Roli Books, 2000

A Note on the Scheme of Transliteration

To the best of my knowledge, approximately towards the close of the 18th century, when the Europeans started cultivating Oriental languages, they realized the need for standardizing a scheme of transliteration of Arabic/Persian. Such a scheme of transliteration was, after careful deliberations, unanimously agreed upon at an Oriental Conference held in England attended by renowned Orientalists. By contrast, awareness of standardized procedures is conspicuous by its absence in Hindi and Gujarati literary circles where inexact and even misleading transliteration is widespread. A transliteration scheme is acceptable as long as it ensures uniformity in representing long and short vowels and those letters which are apparently similar but distinctly dissimilar in pronunciation. Replacing or interchanging such letters in a word not only constitutes misspelling but at times results in disastrous change of meaning. A scheme can be said to be perfect if it enables a layman to rewrite in the original language with exactness. Intervening ع when pronounced as ā is represented by �ไ, otherwise by a dot beneath अ. For instance 'bā'd' means 'afterwards' and 'bād' means 'wind'. Or is فْتادہ spelt as फ़्तादह and not as फ़्ताda. Ending ہ hay-i-hawwaz which is pronounced as ā is retained in order to differentiate from ending الف which is also pronounced as ā to facilitate proper transliteration. I have attempted to adopt a uniform system throughout in the hope of generating awareness of its importance. The following table shows the scheme of transliteration adopted in this book.

Zubair Qureshi

Scheme of Transliteration

ر / र	د / द	خ / ख़	ح / ह	ج / ज	ش / ष	ت / त	ا / अ
	ڑ / ड़	خ़ / ख़	ح़ / ह़	ز / ज	س / स	ط / त	ع / अ
	ڈ / ड़	کھ / ख	ہ / ह	ذ / झ	ص / स	ط़ / त़	أ / अॱ
	ڈ / ड	خ / ख	ہ / ह	ز / ज़	ش / श		
				ض / झ़	ص / स़		
				ظ / ज़			
				جھ / झ			
				ژ / झ़			

ع / ऽ	ء / ऽ	ی / य	ل / ल	ک / क	ف / फ़	غ / ग़
، / ,	ء / ,	ے / य	ل / ल	ق / क़	پھ / फ	گ / ग
			م / म		ف / फ़	
			ن / न			
			وؙ / व			

123

अझ्झों समा कहां तेरी वुस्अत को पा सके
मेरा ही दिल है वोह कि जहां तू समा सके

वह्दत में तेरी हर्फ़ दूई का न आ सके
आईनह क्या मजाल तुझे मुंह दिखा सके

मैं वोह फ़तादह हूं कि बग़ैर अज़ फ़ना मुझे
नक़्शे क़दम की तर्ह न कोई उठा सके

क़ासिद नहीं यह काम तेरा अपनी राह ले
उसका पयाम दिल के सिवा कौन ला सके

या रब! यह क्या तिलस्म है इदराको फ़हम यां
दौड़े हज़ार, आप से बाहिर न जा सके

मस्ते शराबे इश्क़, वह बेख़ुद है जिस को हश्र
अय दर्द चाहे लाए बख़ुद, फिर न ला सके

दर्द

वह जो हम में तुम में क़रार था तुम्हें याद हो कि न याद हो
वही चा'दा या'नी निबाह का तुम्हें याद हो कि न याद हो

वह जो लुत्फ़ मुझ पे था पेशतर वह करम कि था मेरे हाल पर
मुझे सब है याद झरा झरा तुम्हें याद हो कि न याद हो

वह नए गिले वह शिकायतें, वह मज़े मज़े की हिकायतें
वह हर एक बात पे रूठना तुम्हें याद हो कि न याद हो

कोई बात ऐसी अगर हुई, जो तुम्हारे जी को बुरी लगी
तो बयां से पहले ही भूलना तुम्हें याद हो कि न याद हो

कभी हम में तुम में भी चाह थी कभी हम में तुम में भी राह थी
कभी हम भी तुम भी थे आश्ना तुम्हें याद हो कि न याद हो

वह बिगड़ना वस्ल की रात का, वह न मानना किसी बात का
वह नहीं नहीं की हर आन अदा तुम्हें याद हो कि न याद हो

जिसे आप गिनते थे आश्ना, जिसे आप कहते थे बावफ़ा
मैं वही हूं मोमिने मुब्तला तुम्हें याद हो कि न याद हो

<div align="right">

मोमिन

</div>

<div align="center">

३

</div>

दा'ईम पड़ा हुवा तेरे दर पर नहीं हूं मैं
ख़ाक ऐसी ज़िन्दगी पे कि पत्थर नहीं हूं मैं

क्यूं गर्दिशे मुदाम से घबरा न जाए दिल
इन्सान हूं, प्यालओ साग़र नहीं हूं मैं

या रब ज़माना मुझ को मिटाता है किस लिये
लौहे जहां पे हर्फ़े मुकर्रर नहीं हूं मैं

हद चाहिये सज़ा में उक़ूबत के वास्ते
आख़िर गुनाहगार हूं, काफ़िर नहीं हूं मैं

<div align="right">

ग़ालिब

</div>

उल्टी हो गईं सब तदबीरें, कुछ न दवा ने काम किया
देखा, इस बीमारिये दिल ने आख़िर काम तमाम किया

अहदे जवानी रो रो काटा पीरी में लीं आंखें मुंद
या'नी रात बहोत थे जागे सुब्ह हुई आराम किया

ना हक़ हम मजबूरों पर तोहमत है यह मुख़्तारी की
चाहते हैं सो आप करे हैं, हम को अबष बदनाम किया

सारे रिन्द अवबाश जहां के तुझ से सुजूद में रहते हैं
बांके तेढ़े तिरछे तीख़े सब का तुझ को इमाम किया

सरज़द हम से बे अदबी तो वहशत में भी कम ही हुई
कोसों उस की ओर गए पर सज्दह हर हर गाम किया

कैसा क़िब्लह, कैसा का'बह, कौन हरम है, क्या एहराम
कूचे के उस के बाशिन्दोंने सब को यहीं से सलाम किया

मीर

साज़ यह कीनह साज़ क्या जानें
नाज़ वाले नियाज़ क्या जानें

शम्अ रु आप गो हुए लेकिन
लुत्फ़े सोज़ो गुदाज़ क्या जानें

कब किसी दर की जुब्ह साई की
शैख़ साहब नमाज़ क्या जानें

जो रहे इश्क़ में कदम रख्खें
वह नशेबो फ़राज़ क्या जानें

जिन को अपनी ख़बर नहीं अब तक
वह मेरे दिल का राज़ क्या जानें

जो गुज़रते हैं दाग़ पर सदमे
आप बन्दा नवाज़ क्या जानें

दाग़

६

है जुस्तजू कि ख़ूब से है ख़ूबतर कहां
अब देखिए ठहरती है जा कर नज़र कहां

है दौरे जामे अव्वले शब में ख़ुदी से दूर
होती है आज देखिए हम को सहर कहां

या रब इस इख़्तिलात का अन्जाम हो बख़ैर
था उस को हम से रब्त मगर इस क़दर कहां

एक उम्र चाहिए कि गवारा हो नीशे इश्क़
रख्ख़ी है आज लझ्झते ज़ख़्मे जिगर कहां

बस हो चुका बयान कसलो रंजे राह का
ख़त का मेरे जवाब है अय नामह बर कहां

कौनो मकां से है दिले वहशी किनारह गीर
इस ख़ान्मां ख़राब ने ढूंढा है घर कहां

हाली निशाते नग़्मओ मय ढूंढते हो अब
आए हो वक़्ते सुब्ह, रहे रात भर कहां

हाली

लाई हयात आए क़ज़ा ले चली चले
अपनी ख़ुशी न आए न अपनी ख़ुशी चले

हो उम्रे ख़िज़्र भी, तो हो मा'लूम वक़्ते मर्ग
हम क्या रहे यहां, अभी आए अभी चले

हम से भी इस बिसात़ पे कम होंगे बद किमार
जो चाल हम चले सो निहायत बुरी चले

बेहतर तो है यही कि न दुन्या से दिल लगे
पर क्या करें जो काम न बे दिल्लगी लगे चले

नाज़ां न हो ख़िरद पे, जो होना है, हो वही
दानिश तेरी न कुछ मेरी दानिशवरी चले

दुन्या ने किस का राहे फ़ना में दिया है साथ
तुम भी चले चलो युंही जब तक चली चले

जाते हवाए शौक़ में हैं, इस चमन से झौक़
अपनी बला से बादे स़बा अब कभी चले

झौक़

टूटे तेरी निगह से अगर दिल हुबाब का
पानी भी फिर पियें तो मज़ा है शराब का

दोज़ख़ मुझे कुबूल है अय मुन्किरो नकीर
लेकिन नहीं दिमाग़ सवालो जवाब का

था किस के दिल को कशमकशे इश्क़ का दिमाग़
या रब बुरा हो दीदए ख़ाना ख़राब का

ज़ाहिद सभी है ने'मते हक़, जो है अक्लो शुर्ब
लेकिन अजब मज़ा है शराबो कबाब का

कतरह गिरा था जो कि मेरे अश्के गर्म का
दरिया में है हनूज़ फफोला हुबाब का

सौदा निगाहे दीदए तहक़ीक़ के हुझूर
जल्वह हर एक झर्रे में है आफ़ताब का

<div align="right">सौदा</div>

<div align="center">९</div>

कभी अय हक़ीक़ते मुन्तज़र, नज़र आ लिबासे मजाज़ में
कि हज़ारों सज्दे तड़प रहे हैं मेरी जबीने नियाज़ में

तरब आश्नाए ख़रोश हो, तो नवा है मेहरमे गोश हो
वह सरूद क्या कि छुपा हुवा हो सुक़ूते पर्दए साज़ में

तू बचा बचा के न रख इसे, तेरा आईनह है वह आईनह
कि शिकस्तह हो तो अज़ीज़तर है निगाहे आईनह साज़ में

न कहीं जहां में अमां मिली जो अमां मिली तो कहां मिली
मेरे जुर्मे ख़ानह ख़राब को, तेरे अफ़्वे बंदह नवाज़ में

जो मैं सर ब सज्दह हुवा कभी तो ज़मीं से आने लगी सदा
तेरा दिल तो है सनम आश्ना, तुझे क्या मिलेगा नमाज़ में

<div align="right">इक़बाल</div>

इब्तेदाए इश्क़ है, रोता है क्या
आगे आगे देखिये होता है क्या

क़ाफ़िले में सुब्ह के एक शोर है
या'नी ग़ाफ़िल हम चले, सोता है क्या

सब्ज़ होती ही नहीं यह सर ज़मीं
तुख़्मे ख़्वाहिश, दिल में तू बोता है क्या

यह निशाने इश्क़ हैं, जाते नहीं
दाग़ छाती के अबष धोता है क्या

ग़ैरते यूसुफ़ है यह वक़्ते अज़ीज़
मीर इसको राएगां खोता है क्या

मीर

तोहमतें चन्द अपने ज़िम्मे धर चले
जिस लिये आए थे हम सो कर चले

ज़िन्दगी है या कोई तूफ़ान है
हम तो इस जीने के हाथों मर चले

क्या हमें काम इन गिलों से अय स़बा
एक दम आए इधर, उधर चले

दोस्तो देखा तमाशा यां का बस
तुम रहो, अब हम तो अपने घर चले

एक मैं दिल रीश हूं चैसा ही दोस्त
ज़ख़्म कितनों के सुना है भर चले

शम्अ की मानिन्द हम इस बज़्म में
चश्मे नम आए थे, दामन तर चले

साक़िया, यां लग रहा है चल चलाव
जब तलक बस चल सके, साग़र चले

दर्द कुछ मा'लूम है यह लोग सब
किस तरफ़ से आए थे कीधर चले

दर्द

१२

अषर उस का झरा नहीं होता
रंज राहत फिज़ा नहीं होता

बेवफ़ा कहने की शिकायत है
तो भी वा'दा वफ़ा नहीं होता

तुम हमारे किसी तरह न हुवे
वरनह दुनिया में क्या नहीं होता

तुम मेरे पास होते हो गोया
जब कोई दूसरा नहीं होता

हाले दिल यार को लिखूं क्यों कर
हाथ दिल से जुदा नहीं होता

क्यों सुने अर्ज़ें मुझतर अय मोमिन
सनम आख़िर ख़ुदा नहीं होता

मोमिन

सबक ऐसा पढा दिया तूने
दिल से सब कुछ भुला दिया तूने

हम निकम्मे हुए ज़माने के
काम ऐसा सिखा दिया तूने

कुछ तअल्लुक़ रहा न दुनिया से
शुग़्ल ऐसा बता दिया तूने

किस ख़ुशी की ख़बर सुना के मुझे
ग़म का पुतला बना दिया तूने

लाख देने का एक देना है
दिले बे मुद्आ दिया तूने

क्या बताऊं कि क्या किया मैंने
क्या कहूं मैं कि क्या दिया तूने

बे तलब जो मिला, मिला मुझ को
बे ग़रज़ जो दिया, दिया तूने

शबे तीरह में शम्अे रौशन को
नूर ख़ुरशीद का दिया तूने

कहीं मुश्ताक़ से हिजाब हुवा
कहीं पर्दह उठा दिया तूने

मिट गए दिल से नक़्शे बातिल सब
नक़्शह ऐसा जमा दिया तूने

मुझ गुनहगार को जो बख़्श दिया
तो जहन्नम को क्या दिया तूने

दाग़

दर्दे दिल को दवा से क्या मतलब
कीमिया को तिला से क्या मतलब

चश्मए ज़िन्दगी है झिक्के जमील
ख़िझ्झो आबे बक़ा से क्या मतलब

बादशाही है नफ़्स की तसख़ीर
ज़िल्ले बाले हुमा से क्या मतलब

है अगर रिन्द दामन आलूदह
हम को चूं ओ चिरा से क्या मतलब

सूफ़ीये शहर बा सफ़ा है अगर
हो, हमारी बला से क्या मतलब

निगहते मय पे ग़श हैं जो हाली
उनको दुर्दे सफ़ा से क्या मतलब

हाली

यह न थी हमारी क़िस्मत कि विसाले यार होता
अगर और जीते रहते यही इन्तेज़ार होता

तेरे वा'दे पर जिये हम, तो यह जान झूट जाना
कि ख़ुशी से मर न जाते अगर ए'तिबार होता

रगे संग से निकलता वह लहू कि फिर न थमता
जिसे ग़म समझ रहे हो यह अगर शरार होता

कोई मेरे दिल से पूछे तेरे तीरे नीमकश को
यह ख़लिश कहां से होती जो जिगर के पार होता

इसे कौन देख सकता के यगानह है वह यकता
जो दूई की बू भी होती तो कहीं दो चार होता

ये मसाइले तस़व्वुफ़, ये तेरा बयान ग़ालिब
तुझे हम वली समझते जो न बादह ख़्वार होता

<div align="right">

ग़ालिब

</div>

<div align="center">

१६

</div>

किसी बेकस को अय बेदादगर मारा तो क्या मारा
जो ख़ुद ही मर रहा है, उसको गर मारा तो क्या मारा

बड़े मूझी को मारा नफ़्से अम्मारह को गर मारा
निहंगो अझ़्दहा ओ शेरे नर मारा तो क्या मारा

न मारा आप को जो ख़ाक हो अक्सीर बन जाता
अगर पारे को अय अक्सीरगर मारा तो क्या मारा

तफ़ंगो तीर ज़ाहिर था न कुछ था पास क़ातिल के
इलाही फिर जो दिल पर ताक कर मारा तो क्या मारा

मेरे आंसू हमेशह हैं बरंगे ला'ल शौक़े ख़ूं
जो गौत़ह आब में तूने गोहर मारा तो क्या मारा

<div align="right">

झ़ौक़

</div>

उस कूं हासिल क्यों कर हो जग में फ़राग़े ज़िन्दगी
गर्दिशे अफ़लाक है जिसकूं अयाग़े ज़िन्दगी

अय अज़ीज़ां, सैरे गुल्शन है गुले दाग़े अलम
सोहबते अहबाब है मा'ना में बाग़े ज़िन्दगी

लब हैं तेरे फ़िल हक़ीक़त चश्मए आबेहयात
खिज़्झे ख़त ने उस सूं पाया है सुराग़े ज़िन्दगी

जब सूं देख्खा नई नज़र भर काकूले मुश्कीने यार
तब सूं जूं सुम्बुल परेशां है दिमाग़े ज़िन्दगी

आस्मां मेरी नज़र में कुब्बए तारीक है
गर न देख्खूं तुझ कूं अय चश्मो चिराग़े ज़िन्दगी

चली

कमर बांधे हुवे चलने पे यां सब यार बैठे हैं
बहोत आगे गए, बाक़ी जो हैं तैयार बैठे हैं

न छेड़ अय निक्हते बादे बहारी, राह लग अपनी
तुझे अटख़ेलियां सूझे हैं, हम बेज़ार बैठे हैं

ख़याल उनका परे है, अर्शे आ'ज़म से कहीं साक़ी
ग़रझ कुछ और धुन में इस घड़ी मैख़्वार बैठे हैं

बसाने नक़्शे पाए रहरवां, कूए तमन्ना में
नहीं उठने की ताक़त, क्या करें लाचार बैठे हैं

यह अपनी चाल है उफ़्तादगी से इन दिनों पहरों
नज़र आया जहां पर सायए दीवार, बैठे हैं

कहीं बोसे की मत जुर'अत दिला कर बैठियो उनसे
अभी इस हद को वह कैफ़ी नहीं, हुशियार बैठे हैं

नई यह चझअ शरमाने की सीख्री आज है तुमने
हमारे पास साहब बरनह यूं सौ बार बैठे हैं

भला गर्दिश फ़लक की चैन देती है किसे इस्शा'
ग़नीमत है कि हम सूरत यहां दो चार बैठे हैं

<div align="center">

इस्शा'

</div>

<div align="center">

१९

</div>

तुझी को जो यां जल्वह फ़रमा न देख्रा
बराबर है दुनिया को देख्रा, न देख्रा

मेरा गुन्चए दिल है वह दिल गिरफ़तह
कि जिस को किसी ने कभी वा न देख्रा

अझिय्यत, मुसीबत, मलामत, बलाएं
तेरे इश्क़ में हमने क्या क्या न देख्रा

किया मुझको दाग़ोंने सरवे चरागां
कभो तूने आ कर तमाशा न देख्रा

हिजाबे रुख्रे यार थे आप ही हम
खुली आंख्र जब, कोई पर्दह न देख्रा

शबो रोज़ अय दर्द दर पे हूं उसके
किसो ने जिसे यां न समझा न देख्रा

<div align="center">

दर्द

</div>

दिले नादां तुझे हुवा क्या है
आख़िर इस दर्द की दवा क्या है

हम हैं मुश्ताक़ और वह बेज़ार
या इलाही यह माजरा क्या है

मैं भी मुंहमें ज़बान रखता हूं
काश पूछो कि मुद्आ क्या है

जब कि तुझ बिन नहीं कोई मौजूद
फिर यह हंगामह अय ख़ुदा क्या है

सब्ज़ओ गुल कहां से आए हैं
अब्र क्या चीज़ है, हवा क्या है

हम को उनसे वफ़ा की है उम्मीद
जो नहीं जानते वफ़ा क्या है

जान तुम पर निषार करता हूं
मैं नहीं जानता दुआ क्या है

मैंने माना कि कुछ नहीं ग़ालिब
मुफ़्त हाथ आए तो बुरा क्या है

ग़ालिब

कोई महरम नहीं मिलता जहां में,
मुझे कहना है कुछ अपनी ज़बां में

क़फ़स में जी नहीं लगता किसी तरह
लगा दो आग कोई आशियां में

कोई दिन बुलहिवस भी शाद हो लें
धरा क्या है इशारात-े निहां में

कहीं अंजाम आ पहुंचा वफ़ा का
खुला जाता हूं अब के इम्तेहां में

दिल-े पुर दर्द से कुछ काम लूंगा
अगर फ़ुरसत मिली मुझ को जहां में

बहुत जी ख़ुश हुवा हाली से मिलकर
अभी कुछ लोग बाक़ी हैं जहां में

हाली

ख़बर-े तहय्युर-े इश्क़ सुन, न जुनूं रहा न परी रही
न तो तू रहा, न तो मैं रहा, जो रही सो बेख़बरी रही

शह-े बेख़ुदी ने अ़ता किया मुझे अब लिबास-े बरेहनगी
न ख़िरद की बख़्यह गरी रही न जुनूं की पर्दह दरी रही

चली सिम्त-े ग़ैब सी क्या हवा कि चमन ज़हूर का जल गया
मगर एक शाख़-े निहाल-े ग़म, जिसे दिल कहो सो हरी रही

वह अजब घड़ी थी मैं जिस घड़ी, लिया दर्स नुस्ख़ए इश्क़ का
कि किताब अक़्ल की ताक़ में, जुं धरी थी त्यों ही धरी रही

किया ख़ाक आतिशे इश्क़ ने, दिले बेनवाए सिराज कूं
न ख़तर रहा, न हझर रहा, मगर एक बेख़तरी रही

<div align="center">सिराज औरंगाबादी</div>

<div align="center">२३</div>

जल्वे मेरी निगाहमें कौनो मकां के हैं
मुझ से कहां छुपेंगे वह ऐसे कहां के हैं

करते हैं क़त्ल वह, त़लबे मग़्फ़िरत के बा'द
जो थे दुआ के हाथ वही इम्तेहां के हैं

जिस दिन से कुछ शरीक हुई मेरी मुश्ते ख़ाक
उस रोज़ से ज़मीं पे सितम आस्मां के हैं

आशिक़ तेरे अदम को गए, किस क़दर तबाह
पूछा हर एक ने, यह मुसाफ़िर कहां के हैं

<div align="center">दाग़</div>

<div align="center">२४</div>

दुनिया में हूं दुनिया का त़लबगार नहीं हूं
बाज़ार से गुज़रा हूं, ख़रीदार नहीं हूं

ज़िन्दह हूं मगर ज़ीस्त की लझ्झत नहीं बाक़ी
हर चंद कि हूं होश में, हुशियार नहीं हूं

इस ख़ानए हस्ती से गुज़र जाऊंगा बेलौष
साया हूं फ़क़त़ नक़्श बदीवार नहीं हूं

वह गुल हूं ख़िज़ां ने जिसे बर्बाद किया है
उल्झूं किसी दामन से मैं चोह ख़्वार नहीं हूं

गो दा'वए तक़्वा नहीं दरगाहे ख़ुदा में
बुत जिस से हों ख़ुश ऐसा गुनहगार नहीं हूं

अफ़सुर्दगीयो झो'फ़ की कुछ हद नहीं अक्बर
काफ़िर के मुक़ाबिल में भी दीं दार नहीं हूं

अक्बर इलाहाबादी

२५

आज भी क़ाफ़्लए इश्क़ रवां है कि जो था
वही मील और वही संगे निशां है कि जो था

आज भी इश्क़ लुटाता दिलो जां है कि जो था
आज भी हुस्न वही जिन्से गिरां है कि जो था

दिले सोज़ां से है पुरनूर शबिस्ताने वुजूद
इश्क़ फिर शम्ए महेराबे जहां है कि जो था

मंज़िलें इश्क़ की ता हदे नज़र सूनी हैं
कोई रहरव यहां है न वहां है कि जो था

ज़ुल्मतो नूर में कुछ भी न मुहब्बत में मिला
आज तक धुंधल्के का समां है कि जो था

फ़िराक़

२६

घिर के आख़िर आज बरसी है घटा बरसात की
मयकदों में कब से होती थी दुआ बरसात की

मुजिबे सोज़ो सुरूरो बाइषे ऐशो निशात
ताज़गी-बख़्शे दिलोजां है हवा बरसात की

शामे सर्मा दिलरुबा था, सुब्हे गर्मा ख़ुशनुमा
दिलरुबातर, ख़ुशनुमातर, है फ़िझा बरसात की

सुर्ख़ पोशिश पर है ज़र्दो सब्ज़ बूटों की बहार
क्यों न हों रंगीनियां तुझ पर फ़िदा बरसात की

देख्नेवाले हुए जाते हैं पामाले हवस
देख कर छब तेरी अय रंगी अदा बरसात की

<div align="center">हसरत</div>

<div align="center">२७</div>

ख़िरदमंदों से क्या पूछूं कि मेरी इब्तिदा क्या है
कि मैं इस फ़िक्र में रहता हूं मेरी इन्तेहा क्या है

ख़ुदी को कर बुलन्द इता कि हर तक़्दीर से पहले
ख़ुदा बन्दे से ख़ुद पूछे बता तेरी रज़ा क्या है

मक़ामे गुफ़्तगू क्या है अगर मैं कीमियागर हूं
यही सोज़े नफ़स है और मेरी कीमिया क्या है

नज़र आएं मुझे तक़्दीर की गहराइयां उसमें
न पूछ अय हमनशीं मुझ से वह चश्मे सुरमह सा क्या है

नचाए सुब्हगाही ने जिगर ख़ूं कर दिया मेरा
ख़ुदाया जिस ख़ता की यह सज़ा है वह ख़ता क्या है

<div align="center">इक़बाल</div>

२८

तंग आ चुके हैं कश-मकशे ज़िन्दगी से हम
ठुकरा न दें जहां को कहीं बेदिली से हम

लो आज हम ने तोड़ दिया रिश्तए उम्मीद
लो अब कभी गिला न करेंगे किसी से हम

उभरेंगे एक बार अभी दिल के चलवले
गो दब गए हैं बारे ग़मे ज़िन्दगी से हम

गर ज़िन्दगी में मिल गए हम इत्तेफ़ाक़ से
पूछेंगे अपना हाल तेरी बेबसी से हम

अल्लाह रे फ़रेबे मशिय्यत कि आज तक
दुनिया के ज़ुल्म सेहते रहे ख़ामुशी से हम

<div align="center">साहिर लुध्यानवी</div>

२९

आज यूं मौज दर मौज ग़म थम गया,
इस तरह ग़मज़दों को क़रार आ गया
जैसे ख़ुश्बूए ज़ुल्फ़े बहार आ गई,
जैसे पैग़ामे दीदारे यार आ गया

जिस की दीदो तलब वहम समझे थे हम,
रू-बरू फिर सरे राहगुज़ार आ गया
सुब्हे फ़र्दा को फिर दिल तरसने लगा,
उम्रे रफ़तह तेरा ए'तेबार आ गया

रुत बदलने लगी रंगे दिल देखना,
रंगे गुलशन से अब हाल खुलता नहीं
ज़ख्म छल्का कोई या कोई गुल खिला,
अश्क उमडे कि अब्रे बहार आ गया

ख़ूने उश्शाक़ से जाम भरने लगे,
दिल सुलगने लगे दाग़ जलने लगे
महफ़िले दर्द फिर रंग पर आ गई,
फिर शबे आरज़ू पर निख़ार आ गया

सरफ़रोशी के अंदाज़ बदले गए
दा'चते क़त्ल पर मक़्तले शहर में
डाल कर कोई गरदन में तौक़ आ गया,
लाद कर कोई कांधे पे दार आ गया

फ़ैज़ क्या जानिये यार किस आस पर,
मुन्तज़िर हैं कि लाएगा कोई ख़बर
मयकशों पर हुवा मोहतसिब महरबां,
दिलफ़िगारों पे क़ातिल को प्यार आ गया

<div align="center">फ़ैज़</div>

<div align="center">३०</div>

मुश्किल है जे बस कलाम मेरा अय दिल
सुन सुन के उसे सुख़न्वराने कामिल

आसान कहने की करते हैं फ़रमाइश
गोयम मुश्किल व गर न गोयम मुश्किल

<div align="center">ग़ालिब</div>